IMAGES
of America

PORT ORCHARD

IMAGES
of America

PORT ORCHARD

Kitsap County Historical Society

ARCADIA
PUBLISHING

Published by Arcadia Publishing
Charleston, South Carolina

Printed in the United States of America

Library of Congress Control Number: 2011934354

For all general information, please contact Arcadia Publishing:
Telephone 843-853-2070
Fax 843-853-0044
E-mail sales@arcadiapublishing.com
For customer service and orders:
Toll-Free 1-888-313-2665

Visit us on the Internet at www.arcadiapublishing.com

*To Harry Ward, whose more than 50 years of photography
captured the true spirit of Port Orchard*

CONTENTS

ACKNOWLEDGMENTS

The Kitsap County Historical Society extends a heartfelt thank-you to the following for making this project possible: the society's board of trustees for your support and sponsorship; executive director Carolyn Neal for providing leadership and guidance; Claudia Hunt and George Willock for selecting the images and writing the text; Eric Dahlberg for providing much-needed technical assistance in scanning photographs; Carolyn LaFontaine for locating archival photographs no one else could find; Nina Hallett for lending her proofreading expertise; Bonnie Chrey for providing background information on images; and Jessica Dewar for providing office assistance. The society would also like to thank retired businessman Don Vaughan for sharing his extensive knowledge of Port Orchard history as well as his photograph collection. And finally, we would like to thank acquisitions editor Coleen Balent at Arcadia Publishing for guiding us through the process and being there when we needed her. Unless otherwise noted, all images appearing in this book were provided courtesy of the Kitsap County Historical Society.

INTRODUCTION

The British explorer Capt. George Vancouver discovered Port Orchard Bay in 1792. While on a shore excursion, Vancouver's ship clerk and surveyor Harry M. Orchard found the entrance to a natural harbor southwest of what is now Bainbridge Island. Vancouver named the harbor Port Orchard in honor of Harry M. Orchard. At that time, the only inhabitants in the area were Native Americans, including the Suquamish, Skokomish, and S'Klallam, tribes.

The town of Port Orchard lies on the south shore of Sinclair Inlet, near the head of Port Orchard Bay. The town was first platted in 1886 by Frederick Stevens. He named the town Sidney after his father, Sidney Stevens. Today, many of the streets in Port Orchard bear the first or last names of early settlers, including Sidney, Frederick, Sroufe, and Cline. Soon after the town's creation, settlers began arriving to work in the forest products industry or to acquire free land under the 1862 Homestead Act. The first settlers in Sidney were the Cline and Sroufe families, who arrived in 1886.

Sidney's early entrepreneurs began opening new businesses to fill the needs of a quickly expanding population. Henry Cline opened the town's first store and C.W. Corbett established the first drugstore. Cline also became the first postmaster in 1888. Thomas Cline, a relative, established the town's first newspaper the *Kitsap County Pioneer*. He also built the town's first wharf, which initially was used by settlers arriving in rowboats and later, the Mosquito Fleet, which was to become the principal mode of transportation in the Puget Sound area. The name was derived from the many steamboats crisscrossing Puget Sound like a swarm of mosquitoes. The Mosquito Fleet continued to provide transportation into the late 1930s, when passable roads allowed more flexible transportation.

Early settlers found that the uplands behind the town provided excellent soil for growing fruit and berry crops. Homesteaders cleared land for berry farms, orchards, and vegetable gardens. They also found that angora goats thrived on the ever-present salal and huckleberry brush. Due to the relatively mild winters and short growing season, berry farmers were able to get their crops to the Seattle markets earlier than those grown in other parts of the state. Transporting their farm products to markets in Seattle and Tacoma was made easy via the burgeoning Mosquito Fleet.

By 1890, the town had enough residents to file for incorporation, and Sidney became an incorporated city on September 15, 1890. The first mayor was Ira Rockwell. The city council consisted of Alfred Larson, D.R. Mackintosh, J.H. Cline, and A.W. Robinson.

The initial order of business for Sidney's leaders was to improve the town's infrastructure. Bay Street, the main corridor through town, was built partly on pilings over the water and flooded during extreme high tides. Streets had never been adequately developed, and Pottery and Blackjack Creeks divided the town into three parts. The city leaders provided funding by initiating a license fee for saloons and a poll tax on each adult male resident.

The first public works project was to reduce the grade of Sidney Hill, which runs perpendicular to Bay Street. Excavated dirt from the grading was used to raise the level of Bay Street above

the high tide mark. Later, projects included construction of the Blackjack Creek Bridge, and building a trolley railroad across the tide flat at the east end of town. The town also purchased property on Blackjack Creek for a waterworks and power plant; however, this project was not put into place until 1911.

As early as 1877, the US government considered building a shipyard somewhere on the West Coast. Based on a survey by Navy lieutenant Ambrose B. Wyckoff, the government narrowed the site selection to somewhere in Puget Sound. In 1888, Congress commissioned three naval officers to select a suitable site on Puget Sound. The process took two years.

One of the sites under consideration was on Sinclair Inlet, directly across from the town of Sidney. Under the banner of his newspaper the *Kitsap County Pioneer*, Adrian Sroufe worked tirelessly along with other town boosters to convince the commission to select this site. The commission agreed, and the decision was reported to Congress in December 1890. In March 1891, Congress appropriated funding to purchase the property on Sinclair Inlet. Sidney residents applauded the decision, looking forward to the creation of many new jobs just across the bay and the prospect of more settlers coming into the area.

In 1892, Port Madison (Bainbridge Island) was the seat of Kitsap County. Port Madison, however, had become a virtual ghost town by that year because of a slowdown in the timber industry. Community members from around the county submitted petitions to move the county seat to either Chico, located on nearby Dyes Inlet, or Sidney. Sidney residents, excited about the prospect of becoming the county seat, acquired land and built a two-story courthouse building before voters decided the new location of the county seat. Amid accusations of vote rigging by all three towns, Sidney won the November 1892 election with 877 votes to Port Madison's 443 and Chico's 43.

In the 1892–1893 state legislature, Sidney petitioned to change the name of its town to Port Orchard. The legislature refused, however, as the town of Charleston, located on the opposite shore of Sinclair Inlet, had previously asked the legislature to rename its town Port Orchard. At the same time, Sidney had petitioned the US Post Office Department to rename the Sidney Post Office the Port Orchard Post Office, which the department granted, not knowing about the legislature's actions. Soon thereafter, all naval correspondence to the fledgling naval shipyard began arriving at the Port Orchard Post Office in Sidney. For the next 10 years, Sidney and Charleston argued over which town should have the name Port Orchard. Sidney, however, retained the upper hand because of the actions of the post office department. By 1902, Sidney had become Port Orchard by default. During the 1902–1903 legislative session, Will Thompson, editor of the *Sidney Independent*, convinced the legislature to officially change Sidney's name to Port Orchard. Note that the captions in this work use the name Sidney for photographs taken before 1902 and Port Orchard for photographs taken after 1902.

In 1895, the entire business district of Sidney was destroyed by fire. The fire started in the Sweaney Store, located in the middle of town, and spread each way along the block. The fire spread so quickly that firefighting efforts were limited to pulling as much furniture and merchandise out of the buildings as possible. Structures destroyed by the fire included the Findley Hotel, Howe's Hardware, Corbett's Drug Store, several fraternal lodges, the Sidney Saloon, and the post office building. The total loss added up to about $20,000, which in today's dollars would reach well into the millions. The cause of the fire was never determined, but residents theorized that it was either from spontaneous combustion or an incendiary device. By 1901, the entire town was rebuilt and prospering again.

The early 1900s saw the development of public utility service in Port Orchard. Telephone service became available in 1905 via an underwater cable installed by Sunset Telephone and Telegraph Company. Electricity arrived in 1908, when the city granted Peninsula Light and Power Company a franchise to provide electrical service. Municipal water service arrived in 1911. The first system consisted of a dam and waterworks at the Blackjack Creek property acquired in the 1890s. After 10 years, this system was replaced by an artesian well system, which remains in place today.

In 1914, Harry Ward opened the town's first movie theater at 733 Bay Street. He named it the

Star Liberty Theater. Ward was also known as the "photographer of Port Orchard." Until he was well into his 80s, Ward would appear at nearly all public events to capture the town's history with his camera.

During World War I and II, Port Orchard's growth kept pace with that of Navy Yard Puget Sound, across the bay. During World War I, the shipyard built more than 2,000 ships and boats for the war effort. During World War II, the shipyard built ships and repaired ships damaged in the Pacific theater. During this time, thousands of civilian employees poured into Kitsap County to work at the shipyard. Local residents did their part by renting out spare bedrooms, basements, garages, barns, and even converted chicken coops to house the workers. Large housing projects were constructed in Port Orchard and Bremerton to house the workers and their families.

Port Orchard has long been the home of parades, community festivals, and celebrations. The Days of 49 festival was held around the Fourth of July from the late 1940s until the early 1960s. The festival included a parade and carnival as well as a beard-growing contest. Businessmen who failed to contribute to the event were rounded-up and thrown briefly into a makeshift jail. The Fathoms of Fun festival replaced the Days of 49 in the late 1960s, in order to provide a more family-friendly event. The highlight of the current Fathoms of Fun festival is a fireworks show on the Fourth of July. Each August, Port Orchard is host to the Cruz Classic Car Show, one of the largest car shows on the West Coast. Visitors can stroll the entire length of downtown Port Orchard and view hundreds of vintage automobiles.

The Mosquito Fleet disappeared many years ago, replaced by modern roads, bridges, and a car ferry system. One remnant remains, however: the restored and refurbished *Carlisle II*, built in 1917, continues to carry foot passengers across Sinclair inlet from Port Orchard to Bremerton six days a week under the operation of the Kitsap Transit System.

To this day, Port Orchard remains a bedroom community for civilian and military personnel connected with Puget Sound Naval Shipyard and the other military installations throughout Kitsap County. Residents also commute to other cities around Puget Sound, and the city of Port Orchard serves as a gateway to the magnificent Olympic Peninsula.

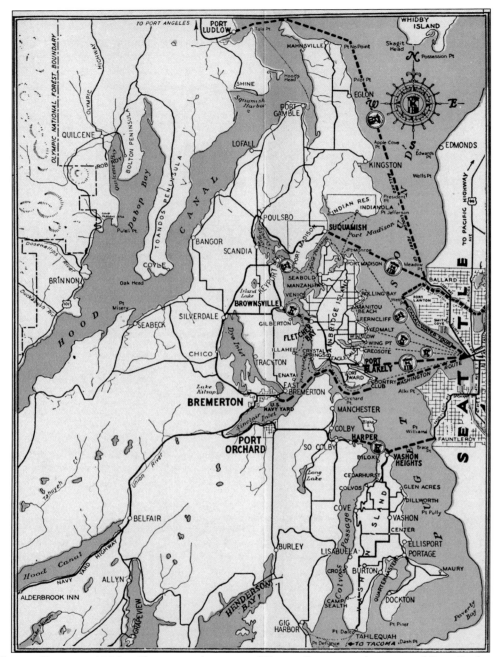

KITSAP COUNTY, 1920s. Shown on this map of Kitsap County is the town of Port Orchard, represented by the grid at lower center. The dotted lines across Puget Sound represent some of the Mosquito Fleet routes. At that time, there were only two paved highways in the south end of the county. One was the Navy Yard Highway, which connected Mason County with the Puget Sound Navy Yard at Bremerton. The other was the Gig Harbor Highway, which ran south to Gig Harbor, then on to Tacoma via ferry. Most other roads were unpaved and were often difficult to negotiate in winter.

One

1888–1910

The years following Sidney's founding in 1886 were turbulent and dynamic. The timber industry was already well established in the area, bringing in hundreds of men to work in the logging camps and sawmills. Settlers were arriving from all over the United States and Europe to file claims on some of the last land available under the 1862 Homestead Act. All of this created a need for goods and services for the new residents. Thus, the town began to grow, starting with the development of Bay Street along the tide flats at the bottom of Sidney Hill. Sidney incorporated in 1890 and became the county seat of Kitsap County in 1893. In 1895, most of the businesses along Bay Street were destroyed by fire; however, most were rebuilt by 1901. By 1902, Sidney had officially changed its name to Port Orchard.

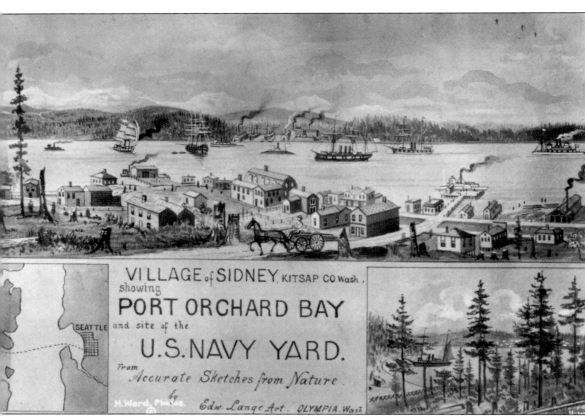

ARTISTS DEPICTION OF SIDNEY'S EARLY DAYS. This poster, created by Edwin Lange of Olympia, Washington, portrays Sidney as it might have appeared around 1890. It includes a fanciful variety of watercraft, ranging from 17th-century sailing ships on the left to a steam-powered ferry on the right. The poster was later photographed by Harry Ward.

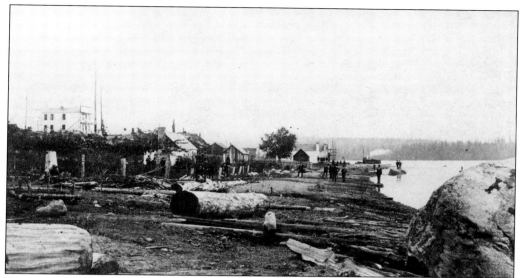

SIDNEY, 1888. In one of the oldest-known photographs of Sidney, what would eventually become Bay Street is shown as little more than a beach. The two-story building on the hill to the left was the home of the *Kitsap County Pioneer*, Sidney's first newspaper founded by Thomas Cline. The steamboat on the right was the *Leif Erickson*, which burned between Seattle and Sidney on Christmas Eve 1888 with the loss of 10 lives.

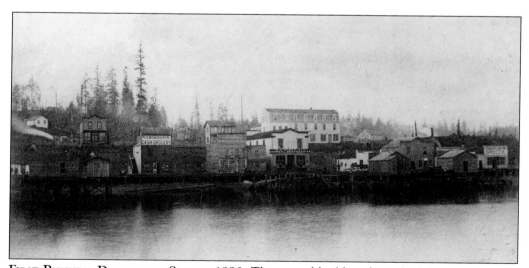

FIRST BUSINESS DISTRICT OF SIDNEY, 1890. The second building from the left was erected in 1890 for the Bank of Sidney, the first bank in Kitsap County. The three-story building in the center is a hotel.

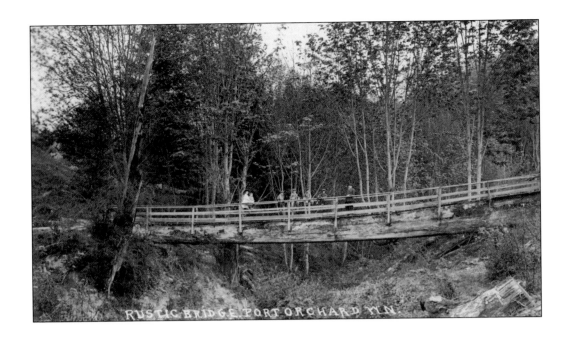

LOG BRIDGES. As early settlers began building roads and trails in and around Sidney, the many creeks and gullies presented obstacles. The easiest way to pass these obstacles was to fell two trees and nail planks across them to form a bridge. Bridge building was often a community effort, with neighbors providing materials and labor. Workmen would often be treated to a hearty community meal when the bridge was completed. These two bridges were likely built in the 1890s to provide safe passage for settlers as well as horses, mules, and livestock.

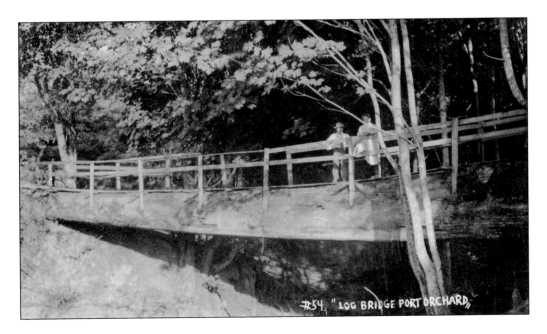

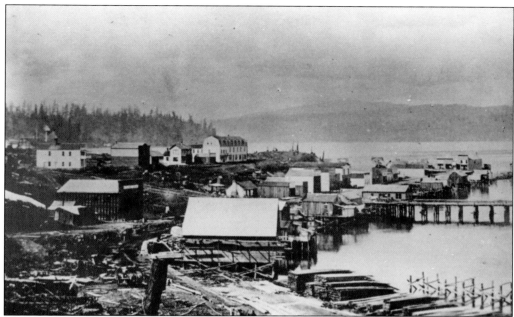

SIDNEY PRIOR TO 1895. The town at this time was a work in progress. Much of Sidney was built over the tide flats, and most of the buildings stood on pilings. Bay Street was constructed primarily from wooden planks resting on pilings. The smoke stacks of the kilns at the Sidney Pottery Works can be seen on the far left.

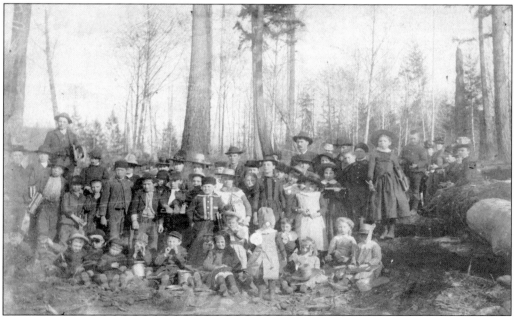

SIDNEY SCHOOL CLASS PICTURE, 1889. Tall fir trees provide the background for the student body and faculty of the Sidney School. The school first opened in 1886. Classes were held 4.5 months a year in a log cabin near Ada Street at the top of Sidney Hill. In 1889, the log cabin was replaced by a larger, wood frame building at the bottom of Sidney Hill near Bank and Prospect Streets.

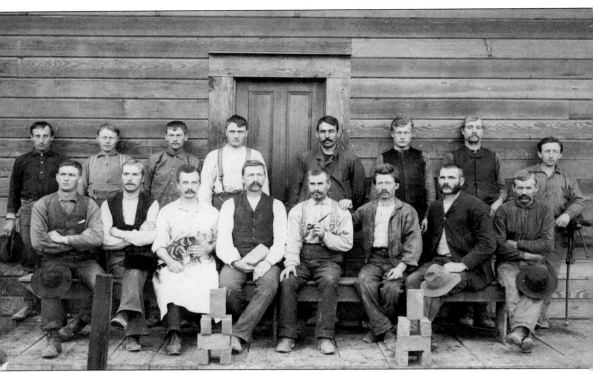

PORT ORCHARD BRICK AND TILE. The high banks along the shoreline of Port Orchard Bay were rich in clay suitable for making tile and bricks. John Noreus established Port Orchard Brick and Tile in 1887 at Waterman, just east of Sidney. The business was short lived, however. After the death of Noreus in the burning of the steamer *Leif Erickson* on Christmas Eve 1888, the business was closed. The work crew included John Brodine, sitting on the far right, who was the first settler to bring his family in to the Waterman area. Sitting next to him is Alfred Larson, yard foreman.

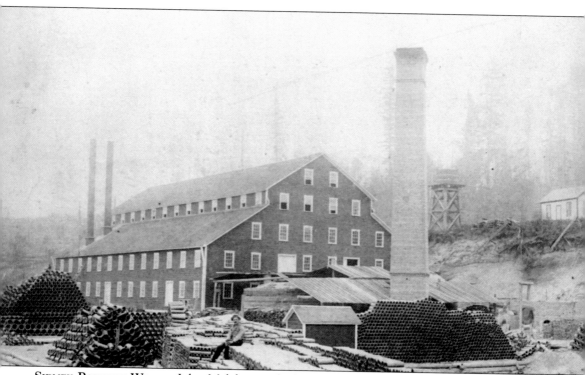

SIDNEY POTTERY WORKS. John Melcher, with the support of local businessmen, founded the pottery works in 1890 at the foot of what is now known as Pottery Hill. The four-story building was equipped with several kilns and turned out high-quality brick, drain tile, sewer pipe, and crockery. Coal was shipped over from Seattle to fire the kilns. The economic slump in the early 1890s slowed the business, which ended suddenly when the building accidentally burned in 1895.

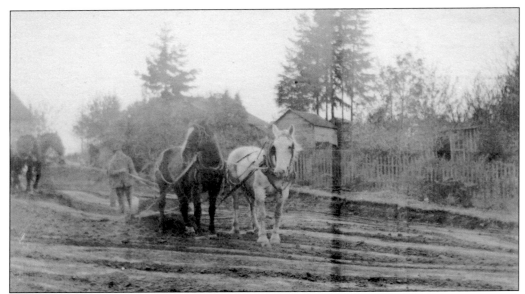

GRADING CLINE HILL, C. 1895. Draft horses are dragging a makeshift wooden blade to smooth ruts at the top of Cline Hill near the courthouse. Prior to the turn of the 19th century, horses and oxen performed much of the work now done by motorized equipment.

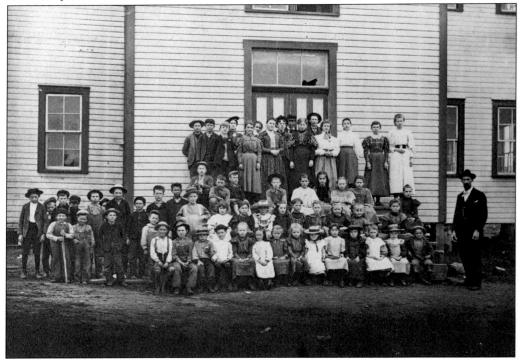

SIDNEY CENTRAL SCHOOL, 1898. Teacher C.N. Winger was also county superintendent of schools. This was the first eighth grade class in Sidney to take the state "Eighth Grade Examination." The students are seen standing on the porch. Part of the seventh grade is also standing on the lower portion of the porch.

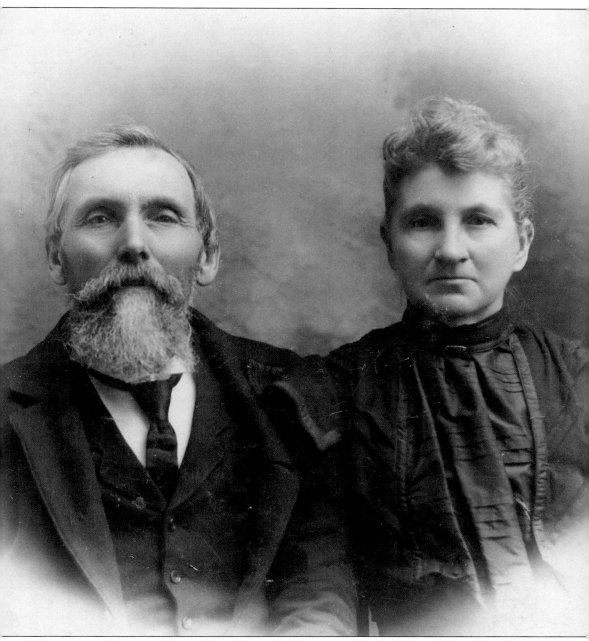

WILLIAM AND MINERVA CLINE. The Clines, also known as "Uncle Billy and Aunt Jane," were among the earliest residents of Sidney. The couple owned the Sidney Hotel on Prospect Street from 1888 until it burned during a fire in 1892. Later, they operated the Brick Hotel for Judge Yakey. Aunt Jane was the accepted midwife and nurse in Sidney. She went when called, making no formal charges; it was general practice, if possible, to pay her $5 for a two-week stay. She was also known for her bread, which she sold in local stores.

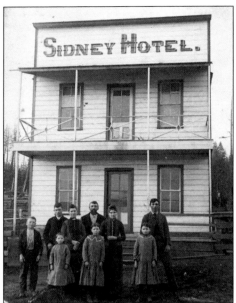

THE CLINE FAMILY. Pictured in 1889 in front of their hotel are William Cline and his eight children, shortly before school. From left to right are (first row) Levi, Emma, Nellie, and Sadie Cline; (second row) George, Jane, William, Rachel, and Albert Cline.

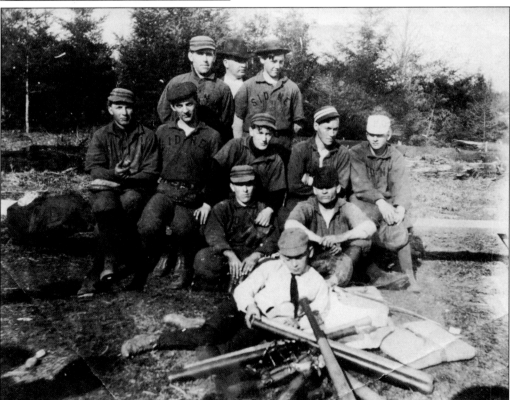

PRE-1900 SIDNEY BALL TEAM. Baseball was a popular activity in Sidney from the town's earliest days. Players in this team photograph include manager Harry Howe in the back row center and Edwin Howe in the front row left.

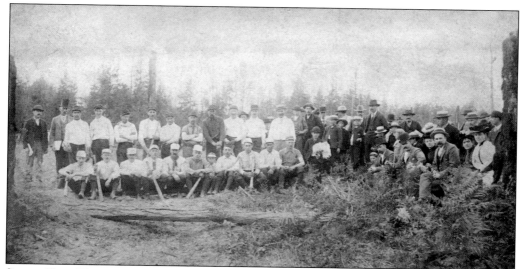

SIDNEY BALL TEAM, JULY 4, 1890. Posing for this photograph are not only the team but also the townspeople who turned out to watch the game. On this particular day, the Sidney Team was defeated 14-10 by the Port Townsend Stars.

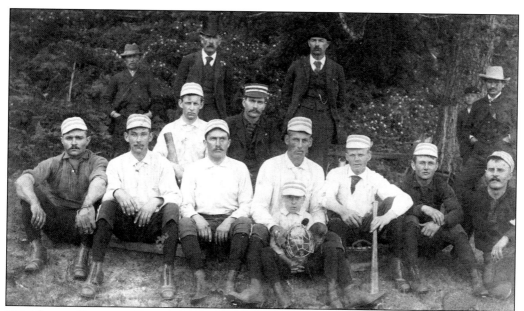

1891 SIDNEY BASEBALL TEAM. Early baseball teams were able to travel to games at towns around Puget Sound on Mosquito Fleet steamers. The teams this club played included Port Blakely, Port Gamble, Seattle, Port Madison, and Old Tacoma. In 1891, the team's record was four wins and four losses.

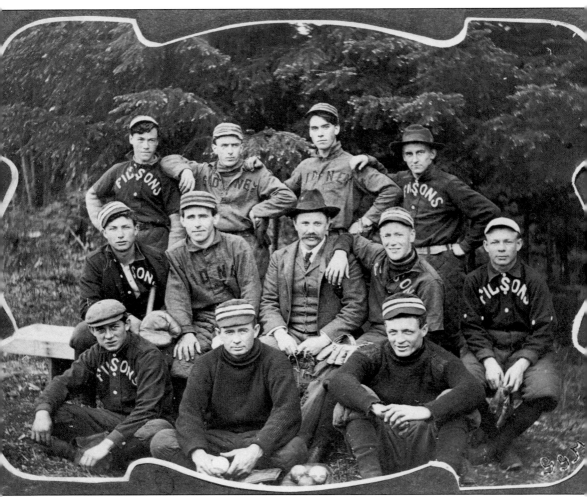

1901 SIDNEY FILSON'S BASEBALL TEAM. Team members include Ted Bain at the far right of the first row; John Kiernan second from left in the second row, Hayden Hughes third from left in the second row and ? McDougal at far right of the second row; and ? Lund at the far left of the third row with Ed Howe next to him.

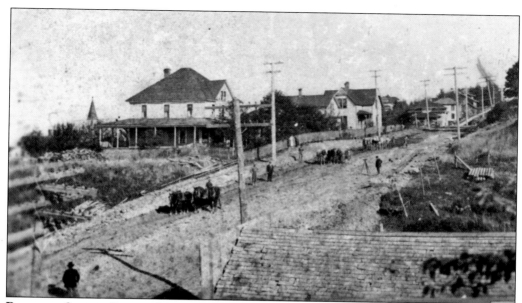

BUILDING SIDNEY STREET, MID-1890S. One of the first public works projects by the newly incorporated town of Sidney was to reduce the slope of Sidney Hill on the south side of town. Fill dirt from the regrading was used to raise the level of Bay Street at the bottom of the hill. Here, teams of horses smooth and level Sidney Street near the top of the hill. In the center to the right, a surveyor uses a transit to sight elevations.

KITSAP COUNTY COURTHOUSE PRIOR TO 1911. Sidney townspeople built this two-story courthouse in 1892, shortly before Sidney was voted in as the new county seat. The sign at the bridge over Division Street shown in the foreground reads, "$5 Fine for Riding or Driving Faster than a Walk."

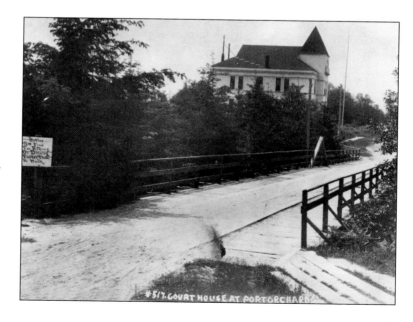

JUDGE JOHN B. YAKEY. After graduating from law school at Columbia College, Missouri, Yakey arrived at Sidney in 1891 and began practicing law. He was elected prosecuting attorney in 1894 and served two terms. He was appointed judge in 1904, was elected in 1905, and served until 1913. Judge Yakey was one of the founding directors of the Kitsap County Bank in 1908 and was known for his generosity in contributing to causes benefiting the community. Shown here, Judge Yakey is joined by his niece Ethyl Kiernan and her son Larry.

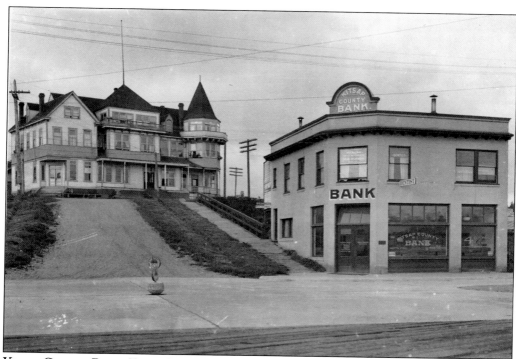

KITSAP COUNTY BANK. Kitsap County Bank, seen here with the Sidney Hotel in the background, was established in 1908. The bank was founded by Jacob Furth, George Miller, Peter Nordby, and Judge John B. Yakey. Frank Langer purchased the bank in 1922 and served as president until his death in 1952. Langer's widow, Hannah Langer, took over as president of the bank in 1952 and served until 1972. She was the first woman bank president west of the Mississippi. Today, Kitsap Bank, as it is now known, thrives at its new headquarters across Bay Street near the former site of the Ainsworth Grocery Store. Kitsap Bank is the oldest and largest locally owned bank in the state of Washington.

INSIDE KITSAP COUNTY BANK. Ornate wood paneling was used on the doors and partitions in this 1909 photograph. Today, Kitsap Bank has more than 20 branches throughout the Puget Sound Region.

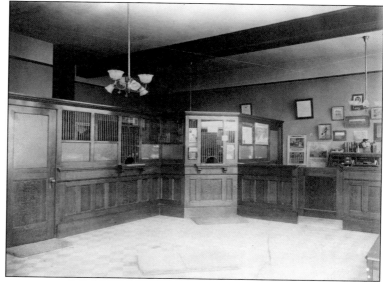

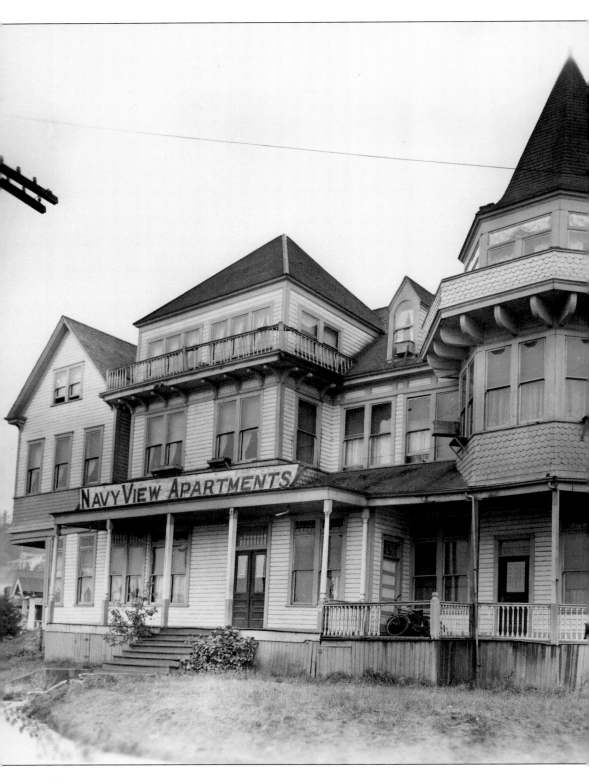

SIDNEY HOTEL/NAVY VIEW APARTMENTS. This landmark structure was built in 1893. It featured 45 rooms, a dining room, ballroom, and a spacious lobby. It was intended as a social center for naval officers from the newly completed Navy Yard Puget Sound and their wives. The hotel, however, was beset with financial problems from the start, beginning with the financial crash of 1893. It was forfeited to the county for unpaid taxes in 1896 and served for a time as home for the county's indigent citizens. At some point, the hotel was renamed the Navy View apartments. In 1907, Roland Hughes purchased the building and reopened it as a hotel and social center for banquets and other public events. After Hughes sold the hotel a few years later, it became the property of a succession of owners and at times was troubled by litigation, including a bankruptcy filing. Rentals were discontinued in the 1930s, and at one time, parts of the building were used as an aviary and mink farm. The building was designated a national historical monument in 1973, but was destroyed by an accidental fire in 1985.

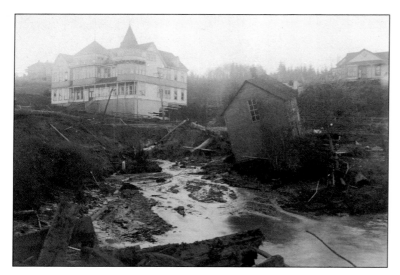

A NEAR DISASTER. In 1910, a mudslide took out much of the foundation of the Sidney Hotel (later Navy View Apartments). Later that year, the owner moved the building two blocks down Sidney Hill to the corner of Frederick and Prospect Streets, using log rollers and a steam donkey engine.

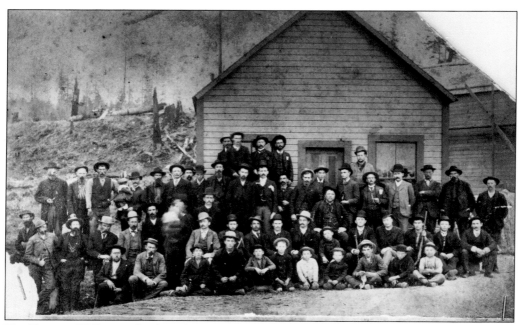

THE BUNCH. William Wheeler, editor of the *Kitsap County Pioneer*, organized a group of citizens to plan the development and advancement of the town. They became known as the "Bunch" and included Jim Dickenson, I.C. Rockwell, J.B. Yackey, Alfred Larson, Dr. S.J. Bridenstine, Ed Aegeter, W.F. Howe, A.W. Robinson, Thomas Cline, Ed Taylor, and William Sutton. They are shown here with family members and other town promoters.

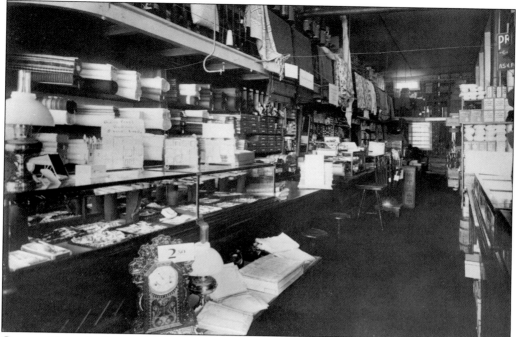

GEORGE MILLER'S GENERAL MERCHANDISE. Mayor of Sidney from 1894 to 1897, George Miller built a large, two-story hardware store. This location at Bay and Sidney Streets later became Blanchard's Department Store. Miller sold the store in 1908, and with his associates, organized the Kitsap County Bank, which he operated until 1914.

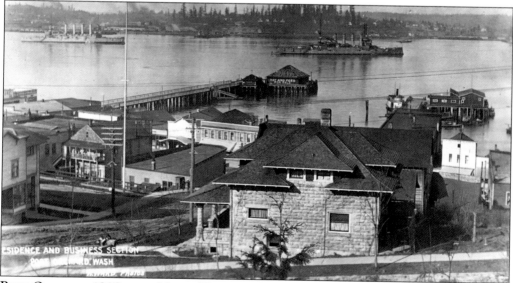

PORT ORCHARD 1908 WITH NAVAL VESSELS. This photograph, taken from halfway up the as yet unpaved Sidney Hill, reveals two anchored, steam-powered, naval warships in Sinclair Inlet. Moored at Port Orchard's Central Dock on the right is a Mosquito Fleet vessel. In 1908, the town passed a "herd law," whereby cattle could roam at large in the streets as long as their cowbells were removed between 9:00 p.m. and 5:00 a.m.

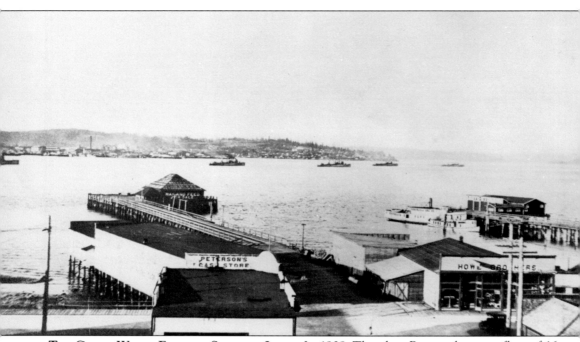

THE GREAT WHITE FLEET IN SINCLAIR INLET. In 1909, Theodore Roosevelt sent a fleet of 16 warships around the world as a gesture of goodwill and to demonstrate the United States's ability to dispatch warships to anywhere in the world. The ships were all painted white and later became known as the Great White Fleet. Pictured are several of the ships anchored in Sinclair Inlet.

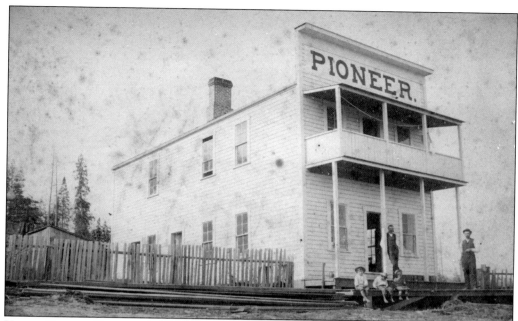

KITSAP COUNTY PIONEER. Thomas Cline launched the Kitsap County Pioneer in August 1886. In 1887, he sold the newspaper to Adrian Sroufe. In 1889, Cline founded a second newspaper, the *Broad Ax*. In 1892, the *Kitsap County Pioneer* and the *Broad Ax* merged under a new name, the *Sidney Independent*, and the new ownership of Walter L. Wheeler. This newspaper continues today as the *Port Orchard Independent*. The *Pioneer's* original building in 1892 was located on Prospect Street, one block up the hill from Bay Street. The building was destroyed in the fire of 1895, which burned most of downtown Port Orchard.

THE INDEPENDENT. Pictured here is the office and printing plant of the *Sidney Independent*. The plant was built on pilings on the south side of Bay Street. This section of Bay Street was nothing more than a catwalk. The building was eventually destroyed by fire in 1911.

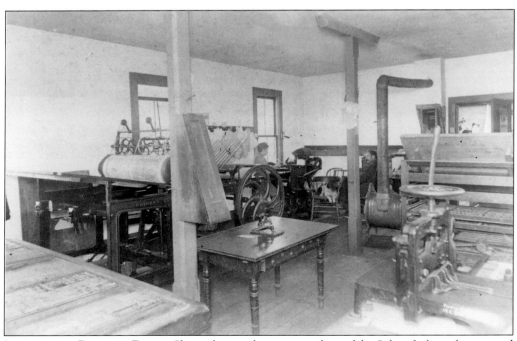

WALTER L. WHEELER. Walter L. Wheeler, on the left, purchased the *Kitsap County Pioneer* and the *Broad Ax* in 1891, and in 1892, merged the two papers to form the *Sidney Independent*. Wheeler continued as owner and publisher until 1899, when he sold the paper to W.L. Thompson and E.E. Brooks. The *Independent* has had many succeeding owners over the years and continues today as Port Orchard's only weekly newspaper.

INDEPENDENT PRINTING PLANT. Shown here is the printing plant of the *Sidney Independent* around 1890. Owner and publisher Walter Wheeler is seated at the back of the room with his dog sitting on the chair nearby. Near the window at left is a young typesetter at work.

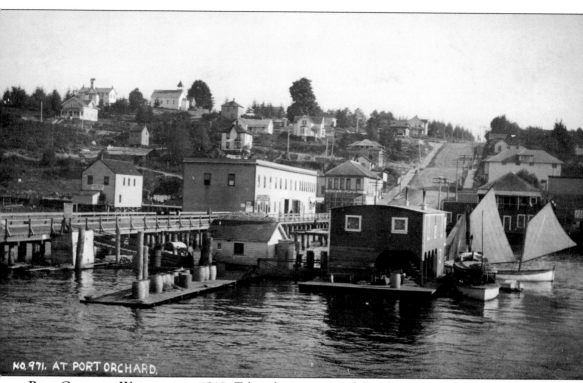

NO. 971. AT PORT ORCHARD.

PORT ORCHARD WATERFRONT, 1910. Taken from a postcard dated October 1910 addressed to Lucy Cline from "Blanche," the floating boathouse shown in the foreground is now the site of the Port Orchard Marina. The large building part way up Sidney Hill on the far right was the Masonic Hall. Today, the building houses the Sidney Museum and Arts Association. At the top of the hill on the left is the schoolhouse that replaced the original log building. The Central Hotel is in the foreground at the head of the wharf.

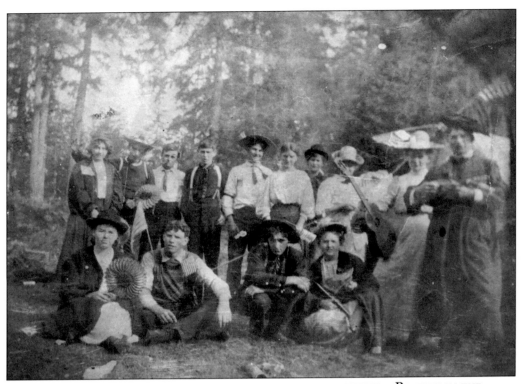

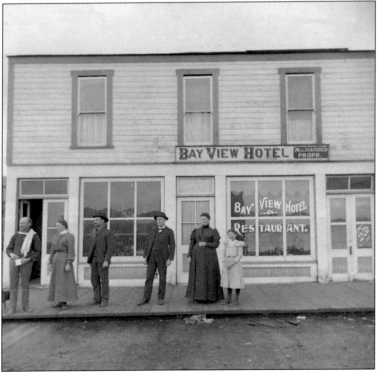

REVELRY IN THE FOREST. Music and thespian productions were common forms of entertainment in the 1890s. Pictured here is a group of young people in a forest setting. Some are holding musical instruments and several appear to be in costume.

BAY VIEW HOTEL. Josephine Barber operated the hotel and restaurant, on Bay Street. On the far right, Josephine appears with her daughter Bessie around 1905. To their right, four passersby and a dog (partially seen) look on.

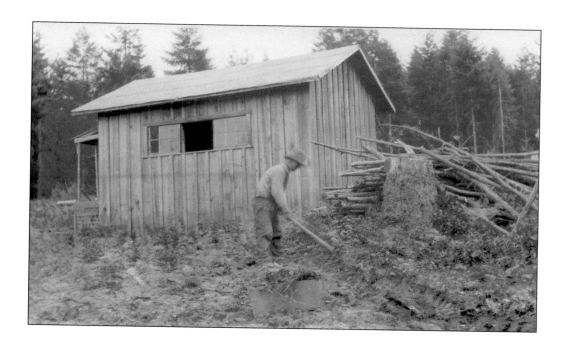

THE LONE SETTLER. A Port Orchard settler tends to his garden next to his tiny cabin around 1910. Later, he pauses to sit on the porch and play his fiddle. A large number of stumps are visible on his property. Most of the old-growth evergreen trees in Kitsap County had been logged by the 1920s, leaving stumps everywhere. Settlers who wanted to establish farms were faced with the task of clearing the stumps to create pastureland. The easiest way to do this was either to dig under them and burn them (a long process) or blow them apart with dynamite when it became available.

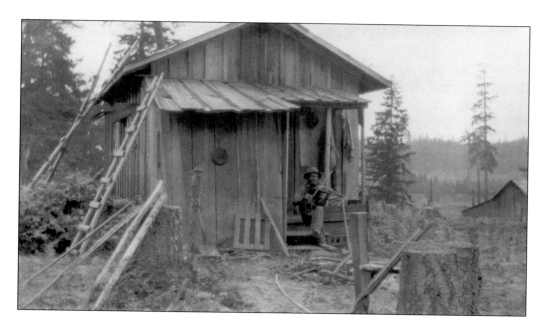

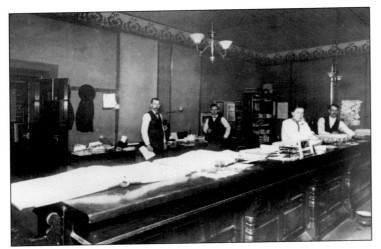

KITSAP COUNTY TREASURER'S OFFICE AND STAFF, 1908. Then as now, the treasurer's office was responsible for collecting county taxes and managing the county's cash assets. Shown from left to right are county treasurer J.M. Peterson, chief deputy treasurer John L. Kiernan, and deputies Reina (Harris) Osborn and W.C. Newman.

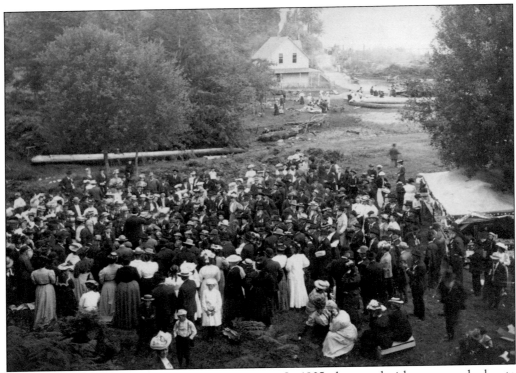

WASHINGTON VETERANS HOME GROUND-BREAKING. In 1905, the state legislature passed a law to allow the building of a state-run home for Civil and Spanish-American War veterans. The ground-breaking ceremony took place on June 28, 1907. More than 200 people attended, standing near the beach at the foot of the hill upon which the home was built. The veterans home was completed in 1910. Additional buildings were added over the years, including a 100-bed hospital in 1949.

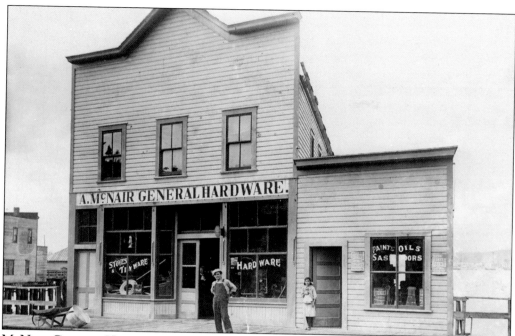

MCNAIR GENERAL HARDWARE.
Canadian Alexander McNair arrived in Sidney in 1891 and opened a hardware store, which he built on pilings on the north side of Bay Street. He was an excellent woodworker, instrument maker, blacksmith, and builder of carts and buggies. He was known as the best horse-shoer on the west side of the state. In 1901, McNair was elected to a term on the Port Orchard City Council. Both photographs show McNair Hardware around 1905. In the above photograph, Loyal Corliss appears in overalls with McNair's daughter Lillian. In the photograph at right, McNair plays one of his handmade violins beside Olive Barth.

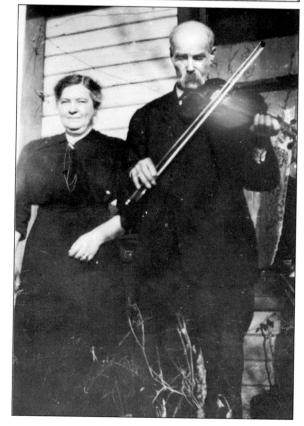

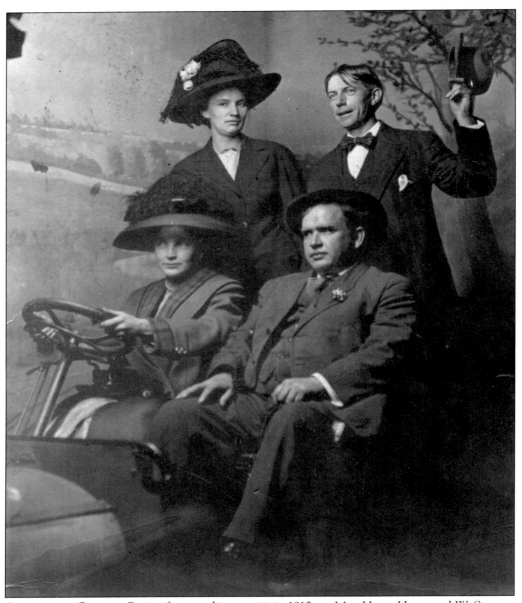

AUTOMOBILE OUTING. Posing for a studio portrait in 1910 are Mrs. Harry Howe and W. Stewart Osborn, both standing in the backseat of an early automobile. Kitsap County treasurer Reina Osborn and businessman Harry Howe are seated in the front.

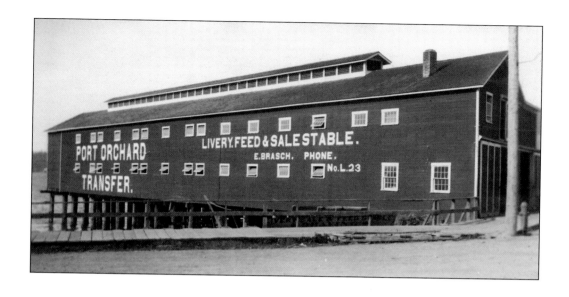

PORT ORCHARD TRANSFER. The building was constructed on pilings at the corner of Bay Street and Harrison in 1905. The company operated a warehouse and transport business as well as a feed store and livery stable. Pictured in 1910 is the building from the outside (above) and a team and driver heading east along Bay Street (below). (Courtesy of Don Vaughan Collection.)

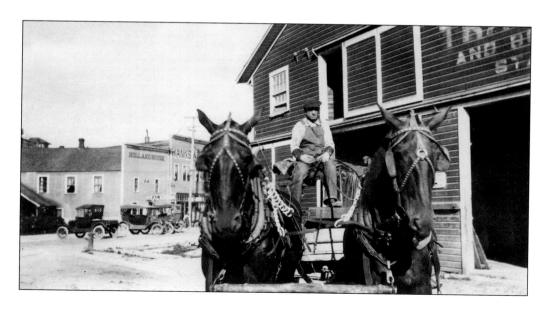

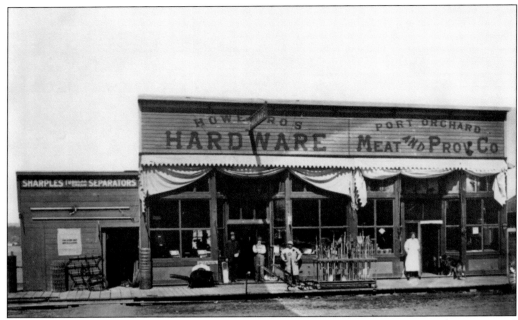

HOWE BROTHERS HARDWARE. W.F. Howe established the original Howe's Hardware around 1890. The store was one of those destroyed in the 1895 fire. In 1908, Howe's sons Edwin and Harry established Howe Brothers Hardware, shown here, at the northeast corner of Bay and Frederick Streets.

BAKER AND COMPANY GENERAL MERCHANDISE. The store was located on the north side of Bay Street. Fourth from the right, manager J.C. Durlam is standing in front of the store. The false-front facades on the adjoining buildings were a common feature on late-19th and early-20th century wood buildings and were intended to project success and stability. By the 1920s, most of the false-front buildings in Port Orchard had been replaced by flat-roofed wood or masonry structures.

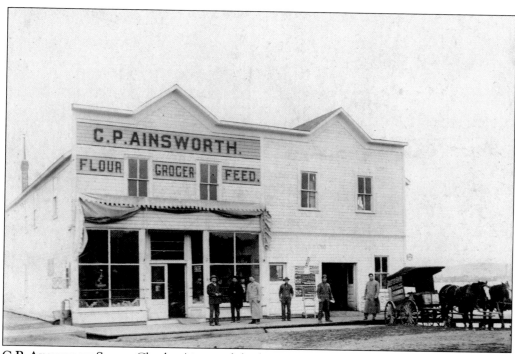

C.P. Ainsworth Store. Charles Ainsworth built a grocery store on the south side of Bay Street, using money he brought back from the Alaska Gold Rush in 1889. The store burned in a fire in 1902, and he promptly built another store across the street. Shown in 1902 are Ainsworth, third from the left, and his son Carl, standing next to the delivery wagon on the right. Carl Ainsworth would eventually take over the store in 1924 and operate it for more than 50 years.

Interior of Ainsworth Store. The store carried a full line of groceries, feed, and other supplies. The string looped down from the ceiling was to aid clerks in wrapping purchases. Pictured from left to right are Charles Ainsworth, May Ainsworth, an unidentified child, Nellie Shroufe, Carl Ainsworth, Mrs. Keely, N.G. Rose, Judge W.A. McLeod, and George ? the deliveryman.

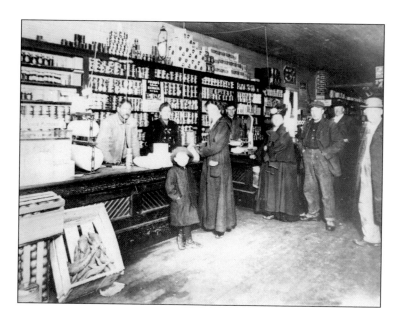

41

THE MASONIC TEMPLE. Built in 1908, the Masonic Temple is located on Sidney Street about halfway up the hill. The temple was built to the strict architectural requirements of the Masonic Lodge, with each floor being of exactly the same square footage and with the front of the building facing east. The building still stands today and is now the home of the Sidney Museum and Arts Association.

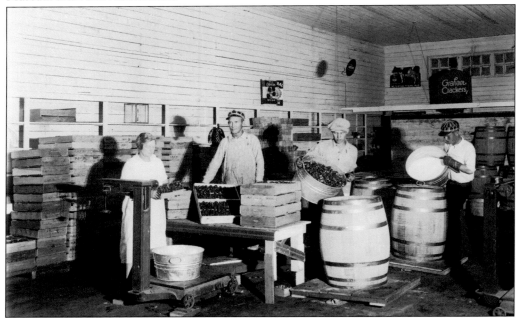

BARRELING STRAWBERRIES, 1910. Each season, Port Orchard berry farmers shipped their crops to markets in Seattle, Tacoma, and around the region. One way to ship them was in barrels for use in the jam and confection industries. Here, a Port Orchard plant is barreling the season's crop for shipment. The woman on the far left is unpacking flats of strawberries brought in by farmers while the foreman observes. The young man in the center is pouring strawberries into a barrel. The young man to the far right is adding sugar in layers to keep the berries from spoiling.

Two

1911–1925

The years 1911 through 1922 brought substantial changes to Port Orchard and its surrounding communities. The increasing use of the automobile as a principle means of transportation necessitated the building of passable roads. Many residents joined the *Good Roads Association* to work with county government in building new roads. World War I brought an increased workload for Navy Yard Puget Sound, which built 2,000 new ships, including launches, submarines, minesweepers, seagoing tugs, and ammunition ships. The first county fair was held in Port Orchard in 1923 and was declared a rousing success. By 1925, the Mosquito Fleet had reached its apex as the primary mode of travel in the region.

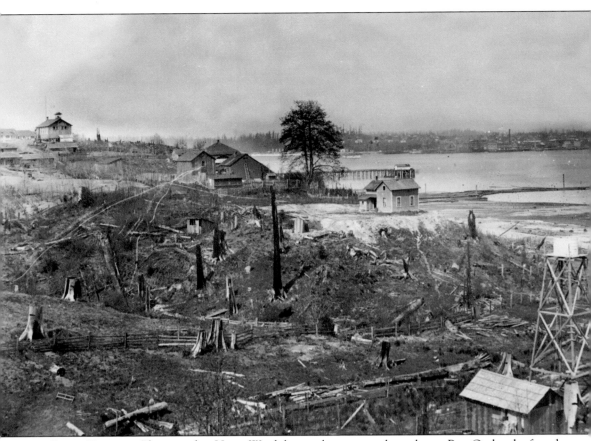

STUMP FARMING. Photographer Harry Ward shows why many early settlers at Port Orchard referred to their homesteads as "stump farms." The photograph was taken below the Retsil Veterans Cemetery, near what is now the intersection of Beach Drive and Olney Roads. On the far left is the Annapolis schoolhouse and behind that, buildings of the newly erected Washington Veterans Home. In the background across Sinclair Inlet is the Navy Yard Puget Sound. Anchored in the inlet are several naval warships.

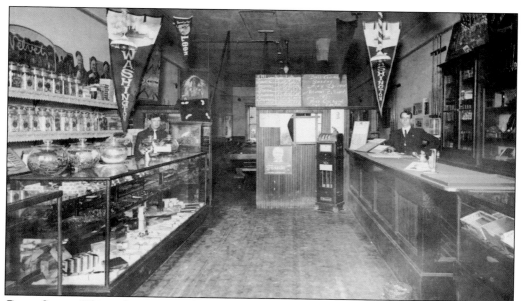

CIGAR STORE. This is the interior of the cigar store, located on Bay Street between Frederick and Sidney Streets. Above the divider in the rear center, the point scores are posted for the Northwest League baseball teams. Next to the scoreboard, a blackboard announces a ball game on May 22, 1915, between "National Billiards" and Port Orchard.

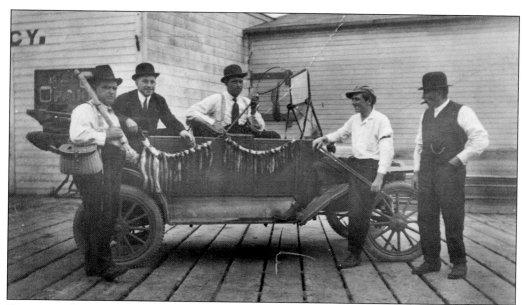

FISHERMEN SHOWING OFF THEIR CATCH. Harry Howe is on the far left, along with four friends on the dock at the foot of Frederick Street. It is not known whether Howe caught all 32 fish or if it was a team effort.

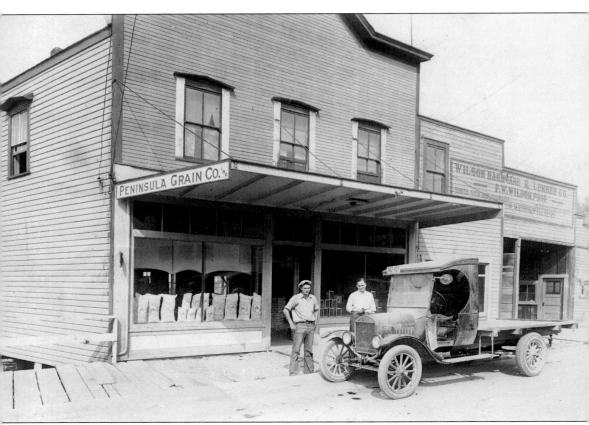

PENINSULA GRAIN COMPANY. Charles G. Vaughan founded Peninsula Grain in 1923. The business first operated from a building at the end of Central Dock. Vaughan later purchased the former Port Orchard Transfer building one block east to house the grain mill. In 1934, Vaughan changed the name of the business to Peninsula Feed. In the 1930s, the stern-wheeler steamboats, *Skagit Queen* and *Skagit Chief* delivered 100 tons of fish meal at a time to the company dock. In addition to selling hay and feed to area farmers, the company collected eggs from area farmers for delivery to Seattle and eventually, to Chicago. At one time, Peninsula was shipping 1,100 cases of eggs per week. From left to right are longtime employee Frosty Adkins and bookkeeper ? Greer in 1927. After Charles Vaughan retired, the business continued under the operation of his son Clyde Vaughan and eventually, his grandson Don Vaughan. (Courtesy of Don Vaughan Collection.)

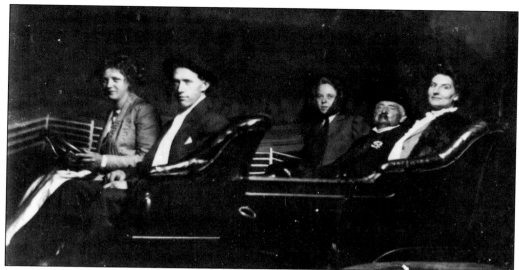

Emma Tohl Sponagle. The Sponagles are shown sitting in the back seat of a 1912 touring car at far right. After the death of Dr. J.D. Sponagle, Emma Sponagle earned a pharmacy degree and purchased the Corbett Pharmacy building on the southwest corner of Sidney and Bay Streets. She then combined Sponagle Pharmacy with Corbett Pharmacy and successfully operated the business for many years.

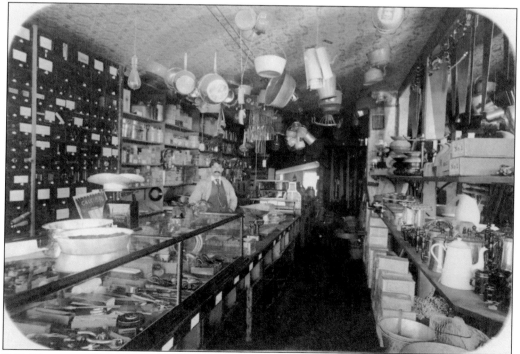

B.F. Harrison Hardware Store. The store contained everything a settler would need to set up a household. Pictured here are a variety of items including kitchenware, carpentry tools, and chain. Note the pots and pans hanging from the ceiling take advantage of all available space.

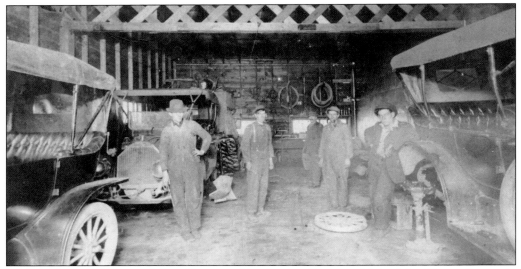

HESTER GARAGE. Loggers Albert Hester and his brother Percy established the Hester Garage in 1909, shortly after automobiles began appearing in Port Orchard. They eventually sold the business to Edwin Howe in 1918 and resumed their logging operations. Their father, Jetson Hester, founded the first sawmill in Sidney in 1888. From left to right are Charlie Anderson, Albert Hester, Jetson Hester, unidentified, and Percy Hester.

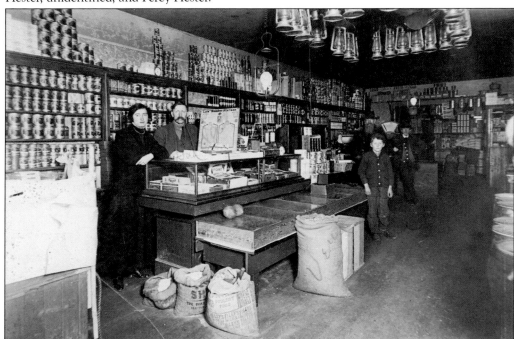

DAVIES STORE. The store started out as a family residence in nearby Gorst. After the 1895 fire, the building was moved by barge to the northwest corner of Bay and Sidney Streets and converted to a store. In the 1920s, it was purchased by the Myhre family and converted to a restaurant. Shown here from left to right are Eunice Stegner, Amos Corliss, Zane Livingston, Art Corliss, and Judge Byrnes.

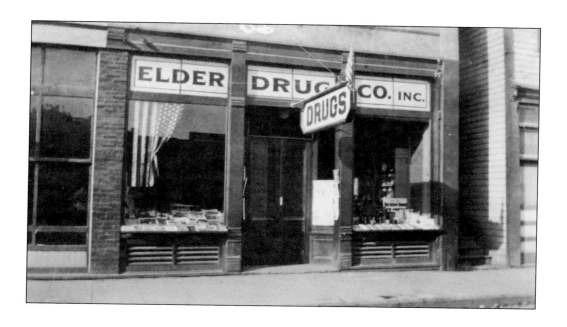

ELDER DRUG COMPANY. Elder Drug was located on the south side of Bay Street on the first floor of the Port Orchard Hotel building. Outside, a magazine display is visible beneath the 48 star flag. On the other side is a display of books and various notions. Inside the store, the soda fountain is to the right with a display case to the left, and the apothecary dispensary is in the middle. The location later became Hacketts Store and, eventually, Port Orchard Variety.

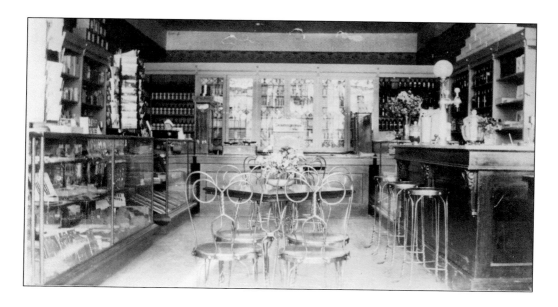

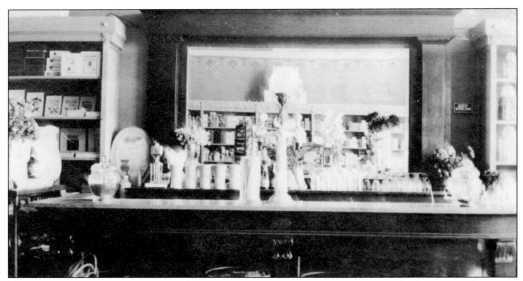

DRUGSTORE SODA FOUNTAIN. Early drugstores nearly always featured a soda fountain. Here, one could purchase a banana split, soda, soft drink, or milk shake for around 5¢. Note the sign that reads "Keep Smiling" on the far right.

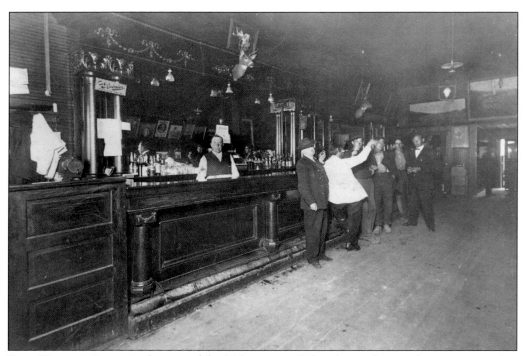

PETE WILSON'S CLUB. At the turn of the 20th century, Sidney boasted nine saloons, supported in large part by the loggers and sawmill workers in the area. Shortly after Sidney's incorporation in 1890, city leaders initiated an annual saloon license fee to help fund the city's infrastructure improvements. This 1914 photograph shows Pete Wilson's Club with Pete Wilson behind the bar.

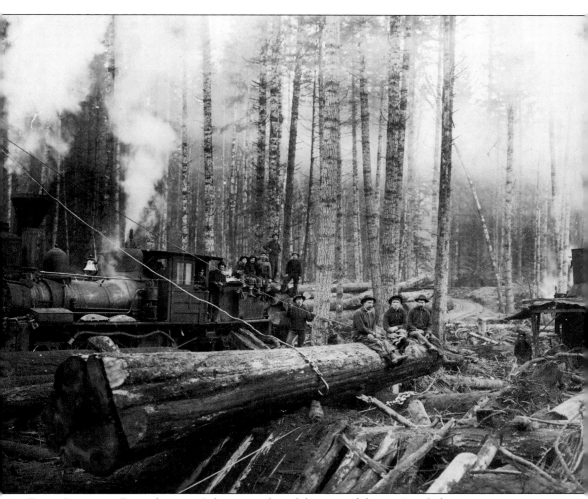

EARLY LOGGING. From the time Sidney was platted, logging of the area's rich forests was a major enterprise. From the early 1890s, logs were dragged out of the forests by oxen and draft horses on "skid roads." By the late 1890s, most of the "easy logs" near the shoreline had been taken, and it became increasingly difficult and expensive to drag logs to local mills and log dumps. To solve this problem, steam locomotives were hauled in by barge, and temporary rail lines were constructed. Tracks were shifted as needed to create new logging sites. A logging crew from Stiles Timber Company of Port Orchard is shown harvesting old-growth Douglas fir and cedar logs. On the far right is a steam-powered donkey engine used to drag logs to the log landing and lift them onto a flat car for transport out of the forest.

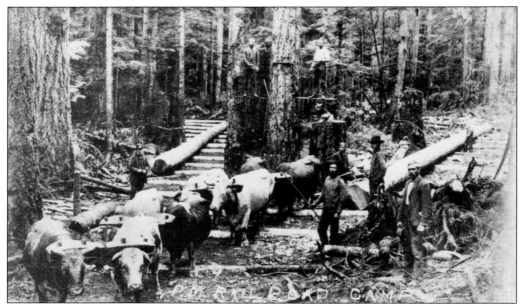

LOGGING WITH OXEN. Before the introduction of logging railroads and steam-powered donkey engines, logs were dragged from the forest using horse or oxen teams. In this c. 1900 photograph of old-growth forest near Sidney, a team of eight oxen is dragging logs along a skid road. Note the two tree fallers standing on springboards eight feet off the ground in the background.

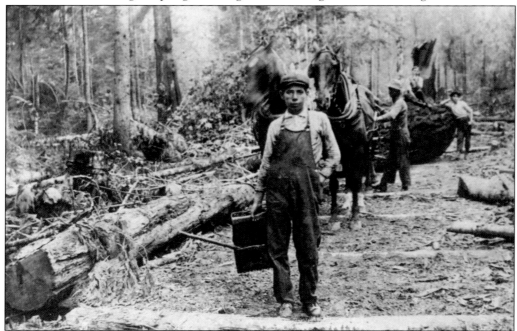

PERCY HESTER, SKID GREASER. In early logging operations, skid roads consisted of small logs (skids) half-buried at fixed intervals along a trail across which logs could be dragged out of the forest by horse or ox teams. Placing oil or grease on the skids reduced friction and made it easier to drag the logs. Dogfish (sand shark) oil was commonly used to grease the skids.

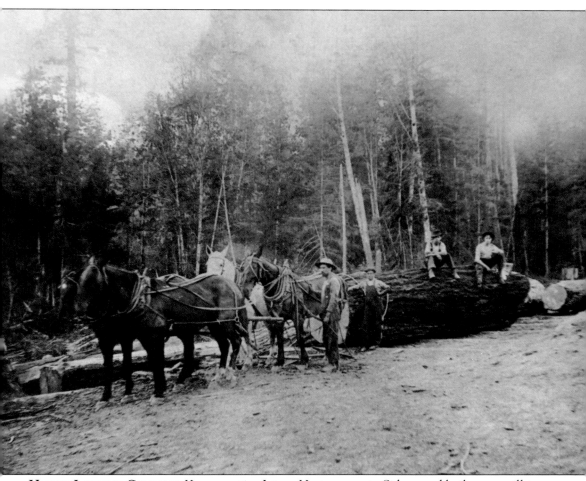

HESTER LOGGING COMPANY. Kansas native Jetson Hester came to Sidney and built a sawmill in 1888. Later, he established a logging operation along with his sons, Albert and Percy, who would later establish Hester Brothers Garage in 1909. Shown standing in the center are Albert (left) and Percy Hester (right) in 1905 with their horse team, about to drag an old-growth log from the forest.

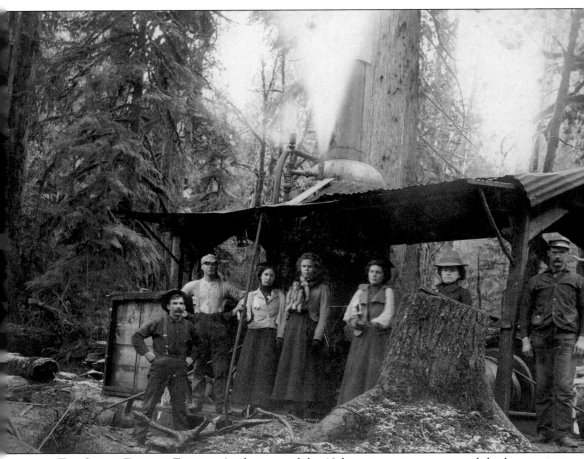

THE STEAM DONKEY ENGINE. At the turn of the 19th century, steam-powered donkey engines replaced oxen for dragging old-growth logs out of the forest. Shown here, employees and family members of Styles Timber Company stand before a steam donkey engine. Note the steam issuing from the valve near the stack, indicating the engine has a full head of steam and is ready to go.

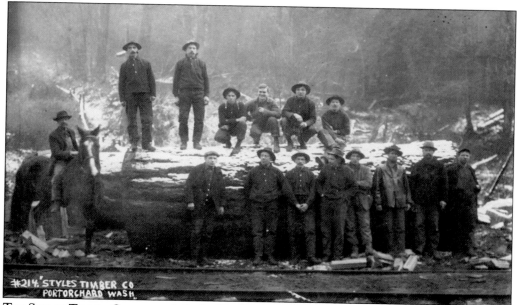

THE STYLES TIMBER COMPANY. A Styles Timber Company crew poses at a logging site southwest of Port Orchard, near what is now McCormick Woods. Note the narrow gauge railroad tracks in the foreground.

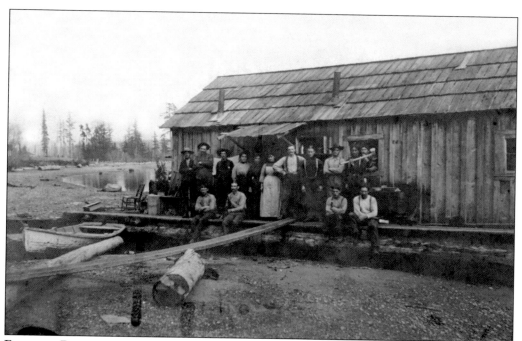

FLOATING BUNKHOUSE, C. 1910. As most of the early logging in Kitsap County was along the shores of Puget Sound, building a floating bunkhouse was an easy way to create a temporary logging camp. When a logging operation was finished, the bunkhouse could be towed to the next site.

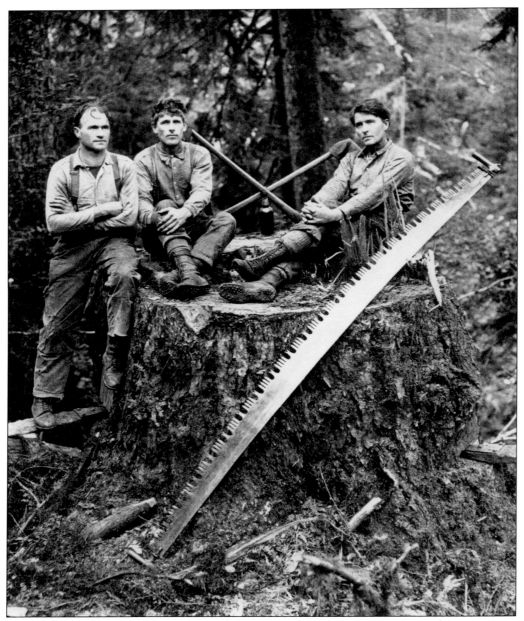

TREE FALLERS, C. 1911. Before the age of chainsaws, cutting down an old-growth tree was not an easy task. Here, a falling crew poses near Port Orchard on a recently cut stump. Note the springboards on either side of the tree. These allow the fallers to cut into the tree where it is smaller in diameter. The double-handle saw in the front was commonly known as a "misery whip." The bottle at center held salmon or dogfish oil used to keep the blade lubricated. The crossed axes in the rear were used to chop the under cut, which controlled where the tree would fall. The steel-lugged boot soles allowed loggers to walk on wet, slippery logs without falling off. The man on the left wears cut-off pants to prevent the hems from snagging on a protruding tree limb stub.

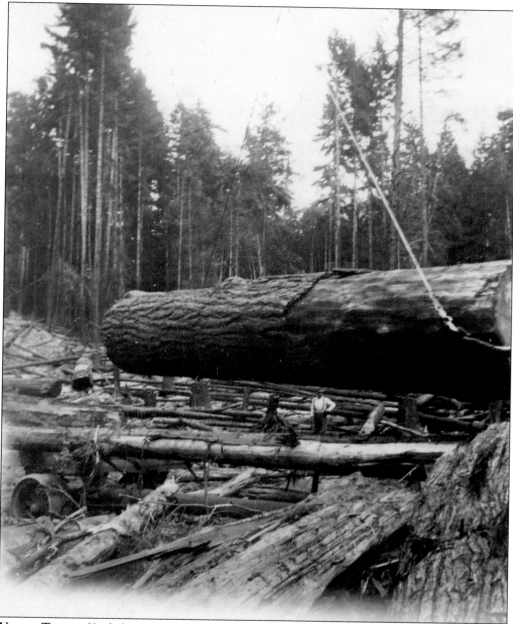

Virgin Timber. Yarded out of the forest, this huge log with a logger standing near it, shows the immense size of old-growth timber. Loggers earned about $2 per day in the early 1900s. The 1901 Business Review Supplement to the *Port Orchard Independent* concluded, "Wages are good and there is no excuse for an able bodied man to be idle here."

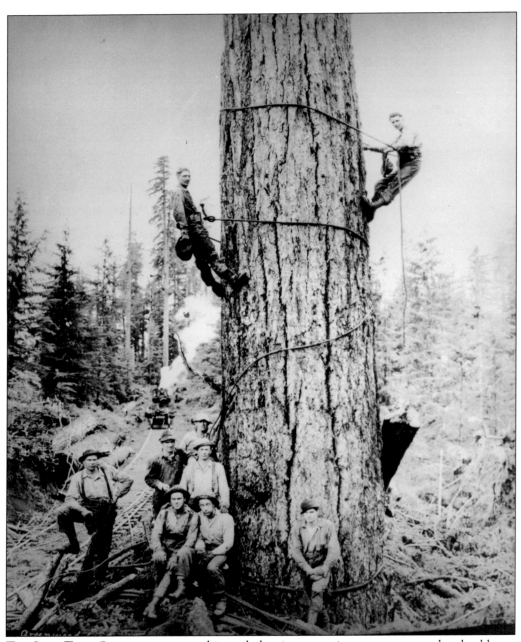

THE SPAR TREE. Spar trees were used in early logging operations to secure overhead cables to blocks, enabling crews to drag newly cut logs to a landing with the aid of a steam donkey engine. The logs could then be lifted onto flat cars pulled by a steam locomotive. Rigging the spar tree required climbing it. Here, loggers wearing climbing spurs demonstrate their technique.

PERCY HESTER, LOGGING TRUCK DRIVER. When the Hesters sold their garage to Edwin Howe in 1918, they resumed their logging operations. By this time, mechanized vehicles had replaced oxen and draft horses for hauling logs out of the forest. Percy Hester is shown here, bringing out a load of logs using a makeshift logging truck. The Hesters were "gypo loggers," a non-derogatory term used in the Pacific Northwest. Gypo loggers were those who purchased relatively small lots of timber. Also, in the Pacific Northwest, lumberjacks are commonly referred to as loggers.

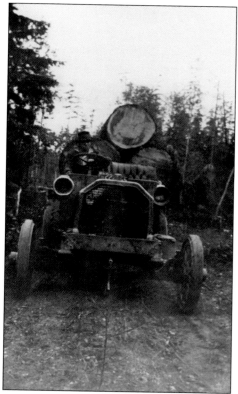

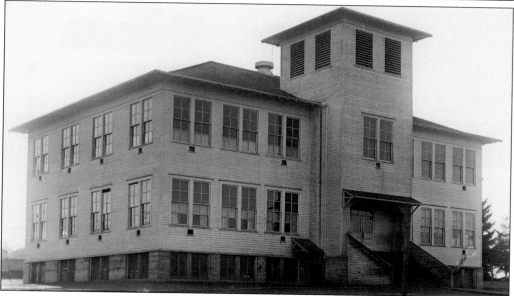

CENTRAL SCHOOL PORT ORCHARD, 1915. Central School was constructed in 1909 on the site near the bottom of Sidney Hill, where the Sidney School once stood. Central School taught all grade levels until South Kitsap Union High School was built in 1921, after which the school only taught through sixth grade.

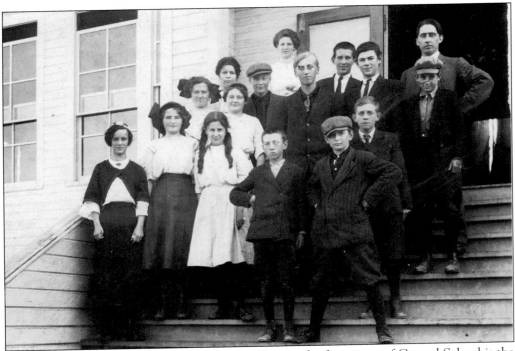

CENTRAL SCHOOL CLASS PICTURE, 1913. Standing on the front steps of Central School is the eighth-grade class. From left to right are (first row) Birdie Willis, Lillian Williams, Mary Kendall, Jim Hussey, and Dean Corliss; (second row) Marjorie McTavish, Ella Fulton, and Jack Burton; (third row) Fay Hummel, Arthur Lundberg, Andrew Greenstad, Earl Maxwell, Dewey Pattison, and Paul Chabot.

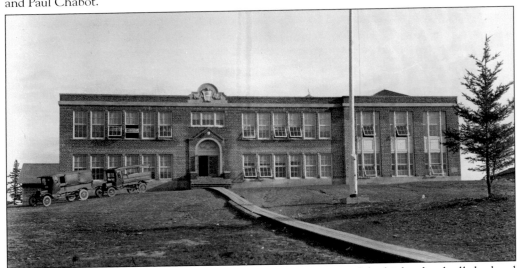

SOUTH KITSAP UNION HIGH SCHOOL. Prior to the construction of the high school, all the local schools in the district taught students from grades one through eight. The new high school brought in all students in the district for grades seven through 12. This 1921 photograph, taken from the top of Mitchell Hill, shows a temporary wooden sidewalk rigged over a yet unplanted front lawn, shortly after the school's construction.

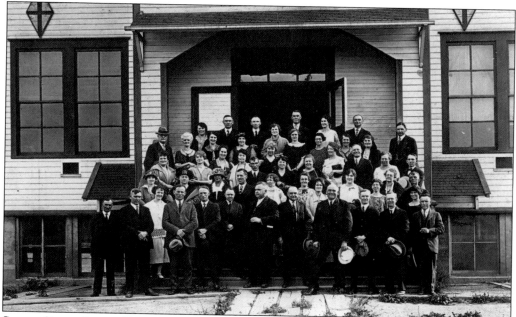

SIDNEY GRADE SCHOOL REUNION. On August 30, 1924, pupils from the Sidney School who attended in the 1880s and 1890s gathered for a reunion. Among those pictured here are Roy, Harry, and Edwin Howe; Lucy, Emma, Nora, George, Sadie, and Levi Cline; Myron and Guy Wetzel; Chloe Sutton; Clyde Schrouf; and Ethel Yakey.

BOAT RENTALS. Before the advent of passable roads in Kitsap County, the easiest way to get around was by boat. Shown here are two Port Orchard boat rental companies' advertisements from the 1913–1914 Kitsap County Business Directory. From these boathouses, one could rent a rowboat or launch or have goods hauled or towed on a barge.

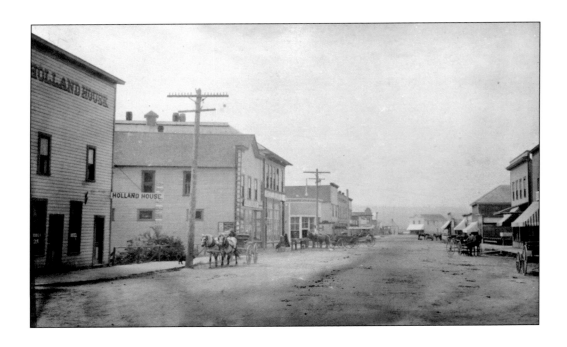

BAY STREET LOOKING WEST, 1900 AND 1914. The Holland House hotel and restaurant is on the left in both photographs. The hotel was owned by Charlotte Bishop and was run by her and her daughter. The site would eventually become the home of Slocums Hardware. Note that in the 1900 photograph above, horses are the only mode of transportation. The Howe Brothers would not open the first automobile dealership in Kitsap County for another 12 years. In the 1914 photograph below are a number of automobiles parked in the unpaved center strip. Note also that the buildings on the right (water) side of the street stand on pilings over the beach. To this day, some of the surviving buildings continue to stand on pilings; fill dirt has been placed under and around them.

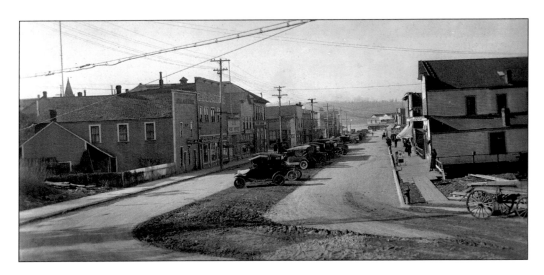

DOWNTOWN PORT ORCHARD, 1915. In the foreground is the Howe Brothers Garage. In 1913, the Howe Brothers were granted a franchise to open the first automobile dealership in Kitsap County. The then 10-year-old Ford Motor Company allowed dealers a $75 markup on each Model T sold.

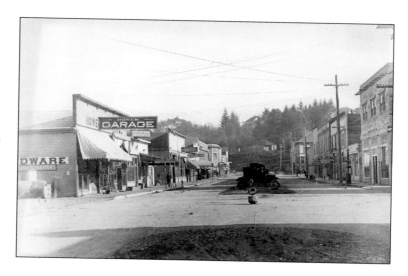

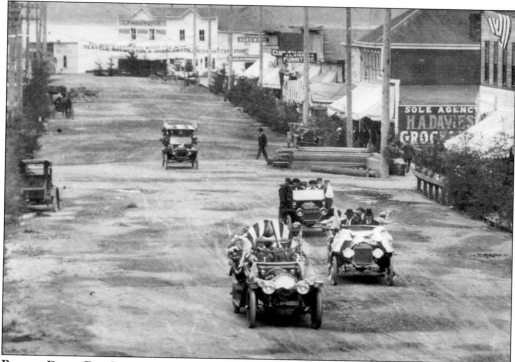

RACING DOWN BAY STREET. On a Fourth of July in the late 1920s, decorated automobiles parade down Bay Street from the west. Driving the lead car is storeowner and banker George Miller. Harry Howe drives the second car. Note the cut evergreen trees that serve as decoration on both sides of the street.

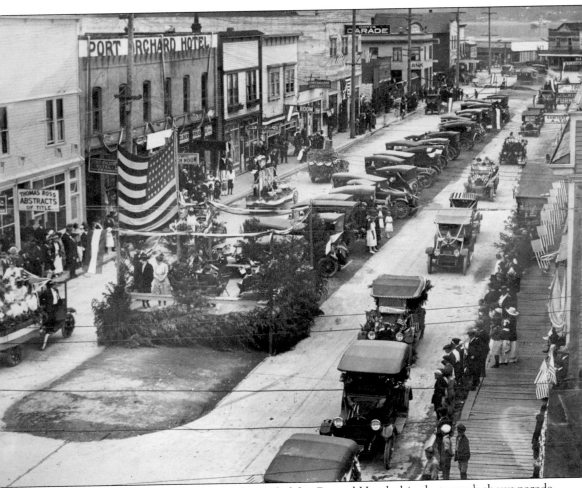

FOURTH OF JULY, 1920. Taken from the roof of the Central Hotel, this photograph shows parade dignitaries watching from the reviewing stand in the street median. The Howe Brothers Garage has moved to a brick building across Bay Street, which the company would later substantially enlarge. Ainsworth Grocery Store can be seen at the bend of the street in the upper right.

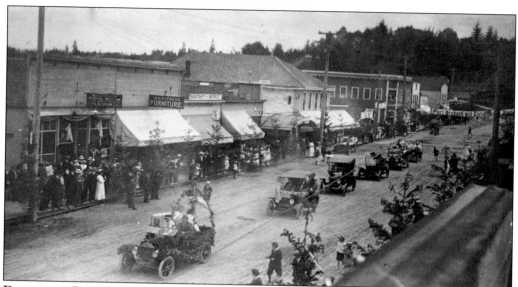

DOWNTOWN PORT ORCHARD, LATE 1920S. Coming from the east, this Fourth of July parade of vehicles reveals Bay Street with the previously unpaved, center parking area covered over. The sanitary market in the center would eventually become Winebrenners Food Center. Notice the banner on the far right that reads "Port Orchard Will Entertain You."

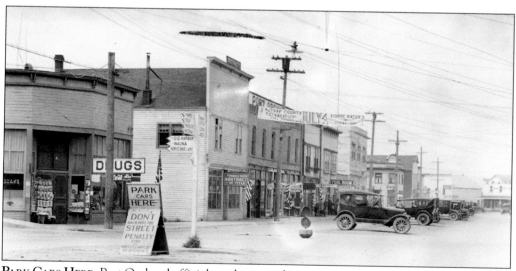

PARK CARS HERE. Port Orchard officials took city parking regulations seriously in the 1920s. The sign in the middle of Bay Street cautions against backing into the street; the penalty was a fine or imprisonment. Next to it, a directional sign points south to nearby communities Gig Harbor, Wauna, Horseshoe Lake; east to Colby, Harper, Waterman and Manchester; and west, no doubt, to Bremerton and Charleston.

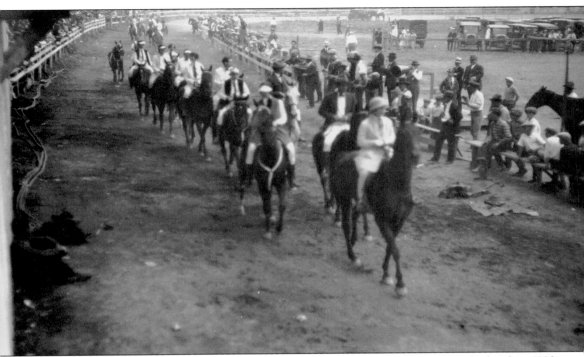

KITSAP COUNTY FAIR. The first official Kitsap County Fair was held in Port Orchard in 1923. The fairgrounds were located at the top of Sidney Hill near the courthouse. By 1929, attendance at the fair was about 1,000. Today, attendance tops 80,000 and is the largest annual interaction of residents from Kitsap County and the surrounding counties. The fair was held at the Port Orchard location until about 1930, when it was moved to Bremerton. Later, Edwin Howe and other Port Orchard businessmen purchased the abandoned fairgrounds and donated the property to the school district for use as a playground. Today, the site is known as Givens Field. In this 1923 photograph, the opening procession of the fair circles the racetrack.

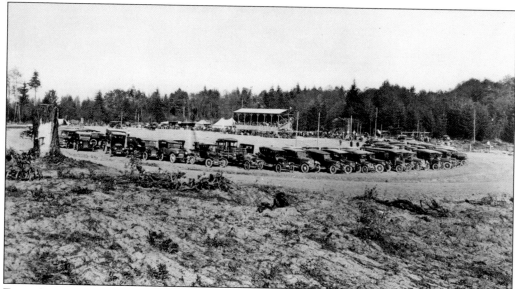

FIRST COUNTY FAIR. After Kitsap County acquired the fairgrounds property at the top of Sidney Hill, land was hurriedly cleared to make room for the 1923 Kitsap County Fair. Shown here is the arena and grandstand with parking around the perimeter. In the background, the big top tent and exhibit sheds can be seen. The fair was a rousing success. It remained at this location for the next six or seven years until it was moved to Bremerton, providing a more central location for county residents.

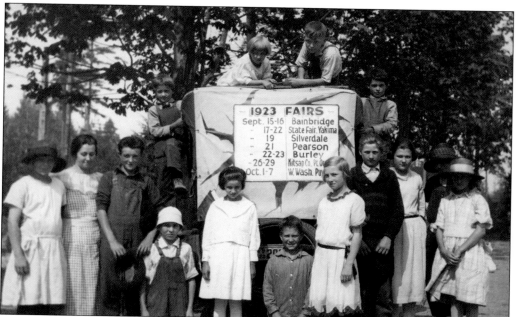

1923 FAIRS. Local and county fairs have long been a staple of agricultural communities. Besides providing entertainment, fairs gave youngsters a place to show their farm produce and animals. Pictured here, a sign advertises the dates of all of the fairs to be held in and around Western Washington, including the first "official" Kitsap County Fair in Port Orchard.

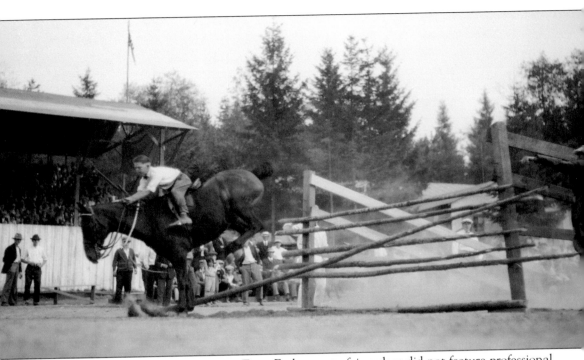

STEEPLECHASE COMPETITION AT THE FAIR. Early county fair rodeos did not feature professional rodeo cowboys or imported livestock. Local residents competed using the livestock from their farms. As seen in this 1924 photograph, the steeplechase and horserace were popular events at the Port Orchard fair.

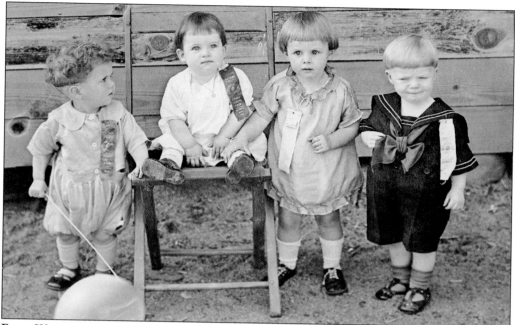

PRIZE-WINNING TODDLERS. Children's beauty contests were a popular feature at early county fairs. The contests often spoke as much to the parents' taste in outfits as the children themselves. Four contest winners show off their ribbons from a 1920s Kitsap County Fair.

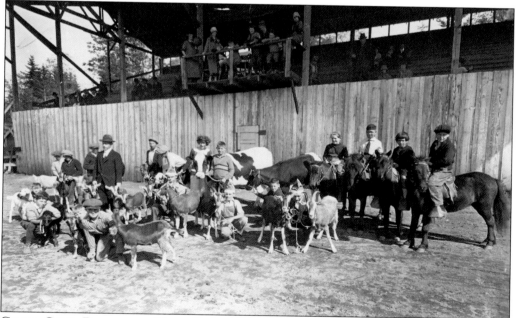

GOATS, COWS, PONIES, AND DOGS. Early settlers around Port Orchard found the area ideal for raising angora goats, as they thrive on the salal and huckleberry bush growing in the forests. Youngsters at the 1925 county fair display their goats, along with ponies, cattle, and an Airedale dog on the far left.

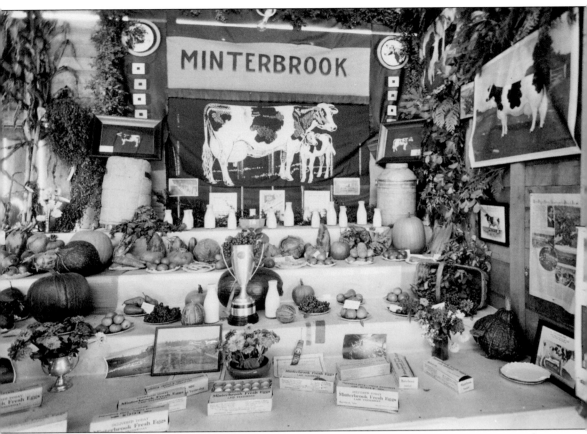

MINTERBROOK DAIRY. Minterbrook Dairy, located south of Port Orchard, produced dairy products, eggs, and garden produce. Pictured here is the prize-winning Minterbrook Dairy display at the 1924 Kitsap County Fair.

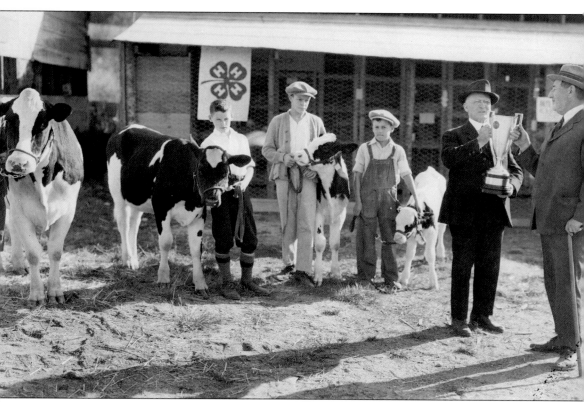

4-H CATTLE. Mr. Seeley (left) and Mr. McCounaghey (right) of Minterbrook Farms display a trophy at the 1923 Kitsap County Fair, while local 4-H Club members look on with their Guernsey cattle. Note the four-leaf clover 4-H Club emblem in the background. The 4-H Club vows, "I pledge my head to clearer thinking, my heart to greater loyalty, my hands to larger service and my health to better living for my club, my community and my country."

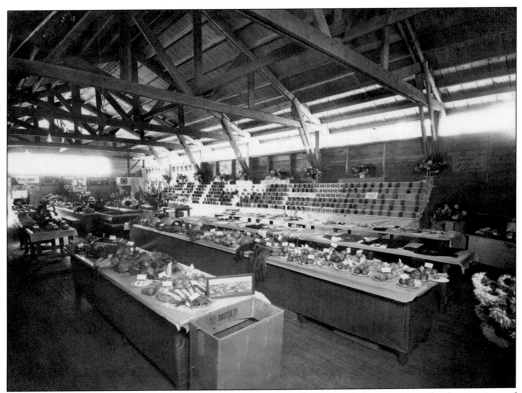

4-H CLUB BUILDING. 4-H Clubs have been around in the United States since the beginning of the 20th century. The focus of the clubs was to promote hands-on learning for youth in a rural environment. 4-H projects included gardening, raising livestock, forestry, canning fruits and vegetables, and sewing, among others. 4-Hers looked forward to displaying their projects at the county fair. Shown here is the 4-H building at the county fairgrounds in Port Orchard. Note the prize fruits and vegetables in the foreground and the rows of fruit canned in glass jars in the background.

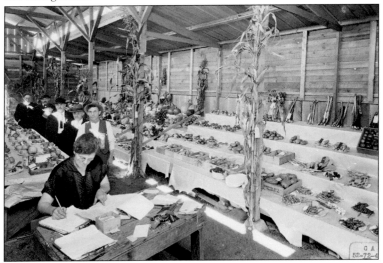

COUNTY FAIR EXHIBIT BUILDING. Sitting at the entry desk at the 1925 County Fair is Mrs. George Worden with her husband, the Kitsap County extension agent, standing behind her. The five people standing behind Worden are presumably waiting to judge the displayed produce.

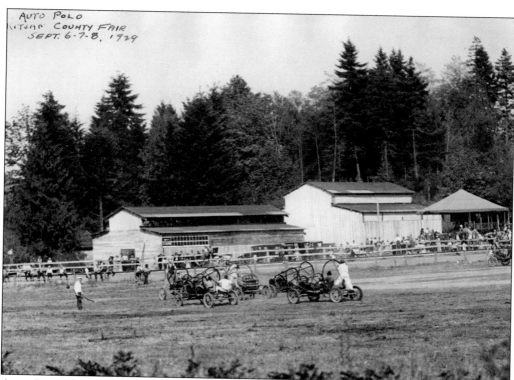

AUTO POLO. For a time in the early days of the automobile, "auto polo" became a popular attraction at county fairs. Here, participants race around the arena at the Kitsap County Fair, chasing a large ball on carts made from cut-down automobile chassis.

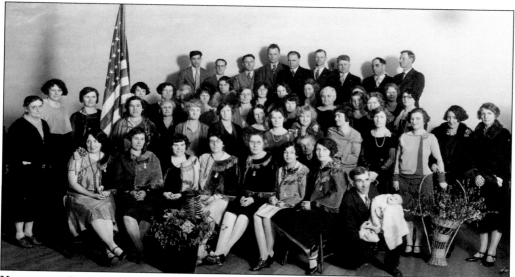

KNIGHTS OF PYTHIAS. Members of the Knights of Pythias appear in the first and last rows with its women's auxiliary organization, the Pythian Sisters. The lodge met in the upstairs meeting hall of the movie theater it built on Bay Street in 1925. The building would eventually become the home of the D&R Theatre in 1928.

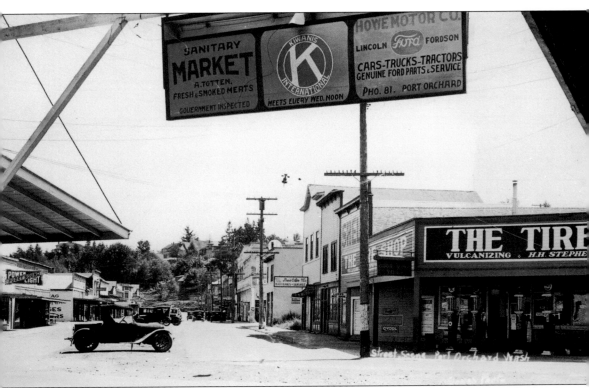

THE AUTOMOBILE. The arrival of the automobile changed the face of downtown Port Orchard. In the early 1920s, automobiles parked along the unpaved center strip. Shown here are a tire store and Shell gas station in the foreground on the right. One block east at Howe Motors, drivers could buy Red Crown gasoline. Besides Ford automobiles, Howe Motors sold Lincolns and Fordson tractors.

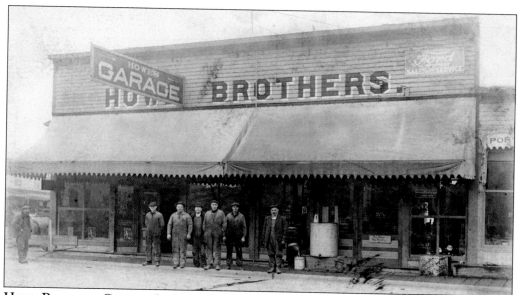

HOWE BROTHERS GARAGE. In 1913, the Howe Brothers were granted the first car dealership franchise in Kitsap County. The Ford Corporation felt that hardware stores were the most appropriate venue for selling cars. To accommodate the expansion of their business, the Howes took over the former meat market next door. Frank Lundberg is the second from the left; Dean Coretti is the fourth from the left.

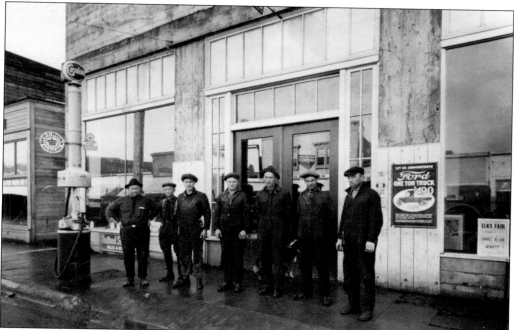

NEW ONE-TON TRUCK FOR $490. This early-1920s photograph shows the mechanics and staff in front of Howe Brothers Garage. Note that a new, one-ton Ford truck was sold for $490. Note also the sign on the gas pump stating "Script Accepted" and the poster for the Elks Fair featuring "Cabaret Deluxe."

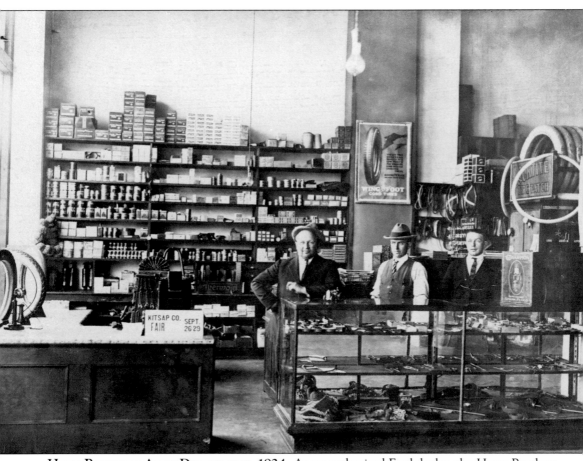

Howe Brothers Auto Department, 1924. As an authorized Ford dealer, the Howe Brothers Garage carried all parts and accessories needed to keep a Model T, Lincoln, or Fordson tractor in running condition. Standing in the center is owner Edwin Howe.

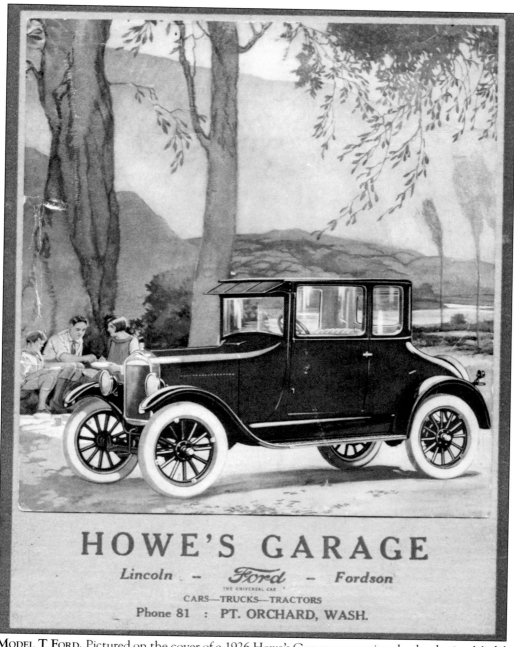

MODEL T FORD. Pictured on the cover of a 1926 Howe's Garage promotional calendar is a Model T Ford coupe, also known as a "Tin Lizzie." The Model T would be replaced a year later by the more modern Model A.

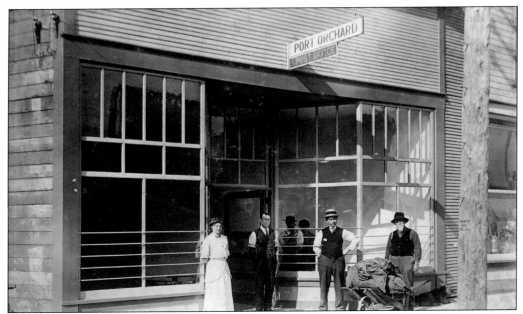

PORT ORCHARD POST OFFICE, 1912. The post office was located on the north side of Bay Street between Sidney and Harrison Streets. From left to right are Ethel Joshlin, Joshua Hanks, postmaster S.L. Pendleton, and mail deliveryman E. Stack.

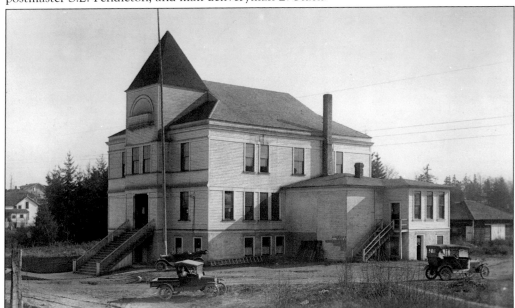

KITSAP COUNTY COURTHOUSE, 1916. Construction on the courthouse began in 1892, before county residents had even voted to move the county seat to Sidney. Located at the top of Sidney Hill on Division Street, the Kitsap County Courthouse was built entirely with the volunteer labor of Sidney residents. The building was considered an architectural triumph for its time, even though it lacked indoor plumbing, running water, central heating, or electricity. The first jail consisted of a steel cage brought in from Seattle with a capacity of two.

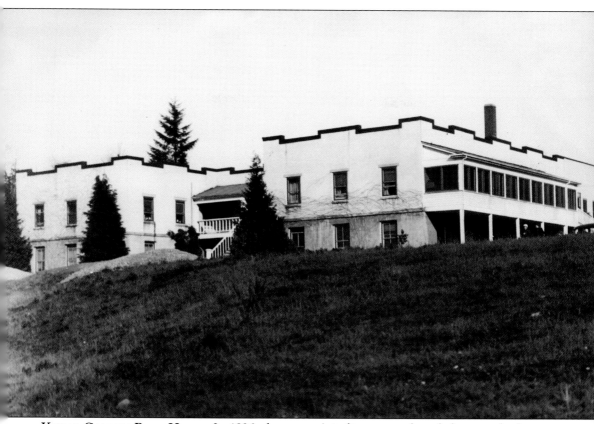

Kitsap County Poor House. In 1896, the county's indigent were boarded out to the lowest bidder among several of the poorer hotels in Kitsap County and Seattle. These hotels furnished the most minimal care. Daniel Davis leased the Sidney Hotel, which, in 1896, had been taken over by the county for back taxes. The paupers were comfortably housed there for several years. This was the beginning of a more humane regime for the care of those dependent on the county's charity. In 1916, Sunnyview Home was established by county government at the top of Mitchell Hill. The home was managed under contract by a series of county citizens, including John and Emma Lundberg, who considered themselves responsible for caring for their charges in a humane and compassionate way. The home also served as a hospital. When the county later bought land for a poor farm, which it named Sunnyview Farm, the Lundbergs were appointed to operate it. Sunnyview Farm was discontinued in the 1930s.

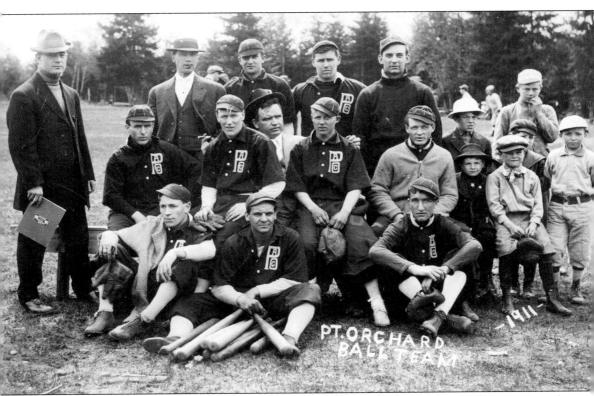

PORT ORCHARD ATHLETIC CLUB 1911 BALL TEAM. The Port Orchard Athletic Club was formed in 1909 and until 1920 was the sponsor of most of the town's athletic events. Club volunteers built a hall on property along Bay Street, where social events such as dances, musical productions, and minstrel shows were held. The club also owned a ball field near the present site of Sunset Lane Cemetery. Pictured in the second row are general manager E.A. Landholt standing on the left, second baseman Ed Howe seated at the left, and manager Harry Howe in the center with a cigar.

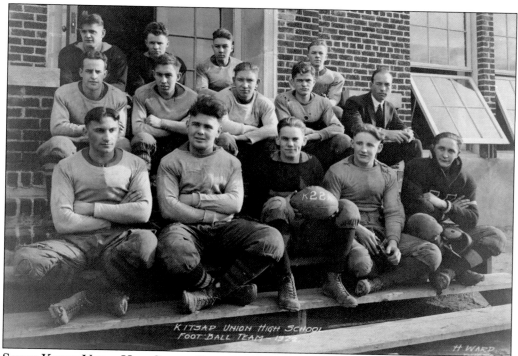

SOUTH KITSAP UNION HIGH SCHOOL FOOTBALL TEAM 1922. Team members are, from left to right, (first row) Leonard Grosso, Demorick Frakes, Irvine Fleming, Lynus Corliss, and Walter Corliss; (second row) George Miller, Earl Baker, Lawrence Lundgren, Charles Peterson, and coach Royal Gunn; (third row) Ralph Peterson, Warren Alderman, Harold Baker, and Maynard Lundberg.

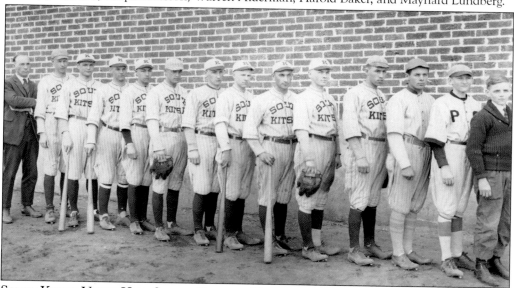

SOUTH KITSAP UNION HIGH SCHOOL BASEBALL TEAM, 1923. Pictured from left to right are coach Royal Gunn, Harold "Scoop" Lidstrom, Cyril Peterson, Irving "Yakie" Fleming, Harold Baker, Ralph Peterson, Lynus "Rowdy" Corliss, Warren Alderman, Leonard "Loby" Grosso, Maynard Lundberg, Earl Baker, Ted Zetterquist, Louis Fleming, and Cyril Fleming.

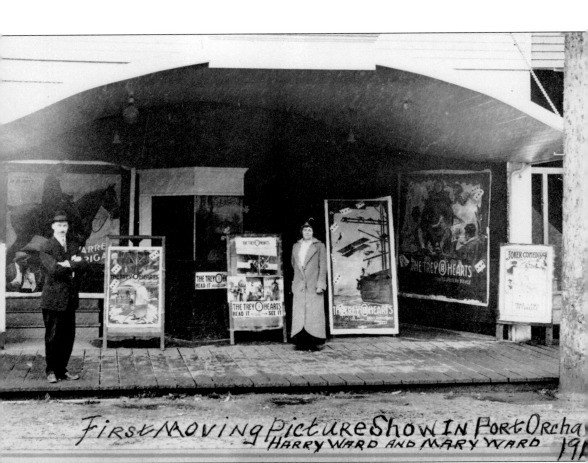

First Moving Picture Show In Port Orcha
Harry Ward and Mary Ward 191

HARRY WARD. Harry and Mary Ward built and opened the Star Liberty Theater in 1914 next to Davies Grocery Store on Bay Street. For 10¢, one could view silent movies such as *The Fall of Troy*, *Birth of a Nation*, and the Mutt and Jeff comedies. Often, families would attend movies two or three times a week. Ward sold the theater in 1919. Ward's other careers included a stint in the Army, a "hoofer" in a dance and comedy team, and a photographer for the *Seattle Times*, *P-I*, and *Port Orchard Independent* newspapers. In the last decade of his 86 years, the burden of cameras did not bow his back nor dim his smile. For many years, he was Port Orchard's unofficial photographer. No one has captured Port Orchard's history more extensively than Harry Ward.

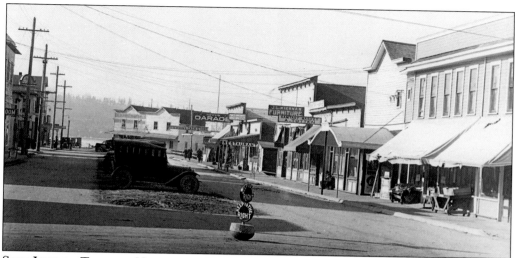

STAR LIBERTY THEATER. Harry Ward's 1914 photograph shows the arched entryway to the Star Liberty Theater in the center right. He operated the theater for five years before selling it to Harry Howe, who resold it a year later to J.A. McGill.

HARRY WARD FILM LOG. Harry Ward kept track of the films he showed at the Star Liberty Theater by making notations in the margins of film distributors catalogs. Shown here is a page from a 1915 catalog. Note that the star of the first film is Mary Pickford.

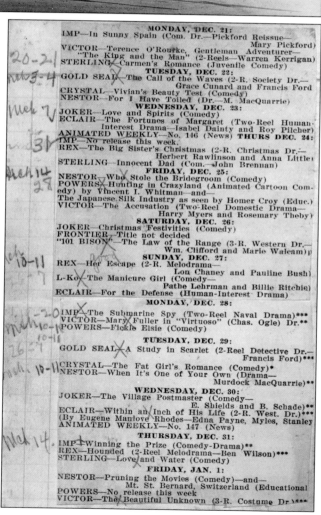

MONDAY, DEC. 21:
IMP—In Sunny Spain (Com. Dr.—Pickford Reissue—
Mary Pickford)
VICTOR—Terence O'Rourke, Gentleman Adventurer—
"The King and the Man" (2-Reels—Warren Kerrigan)
STERLING—Carmen's Romance (Juvenile Comedy)
TUESDAY, DEC. 22:
GOLD SEAL—The Call of the Waves (2-R. Society Dr.—
Grace Cunard and Francis Ford
CRYSTAL—Vivian's Beauty Test (Comedy)
NESTOR—For I Have Toiled (Dr.—M. MacQuarrie)
WEDNESDAY, DEC. 23:
JOKER—Love and Spirits (Comedy)
ECLAIR—The Fortunes of Margaret (Two-Reel Human-
Interest Drama—Isabel Dainty and Roy Pilcher)
ANIMATED WEEKLY—No. 146 (News) **THURS DEC. 24:**
IMP—No release this week.
REX—The Big Sister's Christmas (2-R. Christmas Dr.—
Herbert Rawlinson and Anna Little
STERLING—Innocent Dad (Com.—John Brennan)
FRIDAY, DEC. 25:
NESTOR—Who Stole the Bridegroom (Comedy)
POWERS—Hunting in Crazyland (Animated Cartoon Com-
edy) by Vincent I. Whitman—and—
The Japanese Silk Industry as seen by Homer Croy (Educ.)
VICTOR—The Accusation (Two-Reel Domestic Drama—
Harry Myers and Rosemary Theby)
SATURDAY, DEC. 26:
JOKER—Christmas Festivities (Comedy)
FRONTIER—Title not decided
"101 BISON"—The Law of the Range (3-R. Western Dr.—
Wm. Clifford and Marie Walcam)
SUNDAY, DEC. 27:
REX—Her Escape (2-R. Melodrama—
Lon Chaney and Pauline Bush)
L-Ko—The Manicure Girl (Comedy—
Pathe Lehrman and Billie Ritchie)
ECLAIR—For the Defense (Human-Interest Drama)
MONDAY, DEC. 28:
IMP—The Submarine Spy (Two-Reel Naval Drama)***
VICTOR—Mary Fuller in "Virtuoso" (Chas. Ogle) Dr.**
POWERS—Fickle Elsie (Comedy)
TUESDAY, DEC. 29:
GOLD SEAL—A Study in Scarlet (2-Reel Detective Dr.—
Francis Ford)***
CRYSTAL—The Fat Girl's Romance (Comedy)*
NESTOR—When It's One of Your Own (Drama—
Murdock MacQuarrie)**
WEDNESDAY, DEC. 30:
JOKER—The Village Postmaster (Comedy—
E. Shields and B. Schade)**
ECLAIR—Within an Inch of His Life (2-R. West. Dr.)***
(By Eugene Manlove Rhodes—Edna Payne, Myles, Stanley
ANIMATED WEEKLY—No. 147 (News)
THURSDAY, DEC. 31:
IMP—Winning the Prize (Comedy-Drama)**
REX—Hounded (2-Reel Melodrama—Ben Wilson)***
STERLING—Love and Water (Comedy)
FRIDAY, JAN. 1:
NESTOR—Pruning the Movies (Comedy)—and—
Mt. St. Bernard, Switzerland (Educational
POWERS—No release this week
VICTOR—The Beautiful Unknown (3-R. Costume Dr.)***

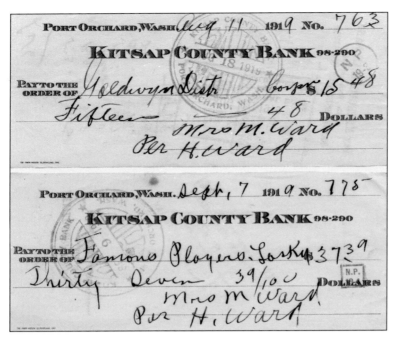

STAR LIBERTY THEATER FILM RENTALS. Harry and Mary Ward obtained the use of films shown at the Star Liberty Theater from studios in Hollywood. Shown here are examples of canceled checks written by the Wards for movies that were shown in the theater.

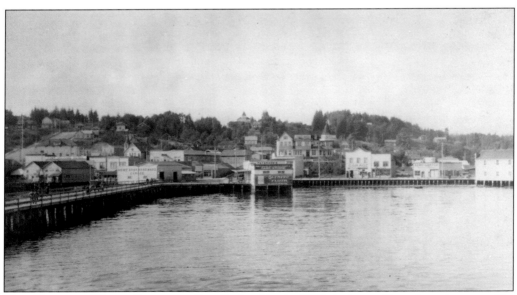

VIEW FROM THE WATER. Downtown Port Orchard in the 1920s is pictured here from the water. On the far left is the dock at the end of Frederick Street. At the head of the dock is Howe Brothers Hardware and Garage. The building marked "Garage" on the center right would later become Modern Plumbing and Supply and even later, the Soo Hoy Café. At the top of Sidney Hill in the center is the Kitsap County Courthouse.

Three

1926–1940

The 1930s saw continued improvements to transportation in and around Port Orchard. Primitive roads were being constructed to outlying communities such as Bethel, Long Lake, and Olalla. The Great Depression of the 1930s did not affect Port Orchard the way it did other towns across the United States, as the Navy Yard Puget Sound was actually in an expansion mode. During that time, several new buildings were constructed at the Navy Yard, as well as the 250-foot Hammerhead Crane, which was completed in 1933 and is still a prominent part of the Bremerton skyline as seen from Port Orchard. By 1940, the aging Mosquito Fleet was nearing obsolescence, replaced by better roads, bridges, and the automobile.

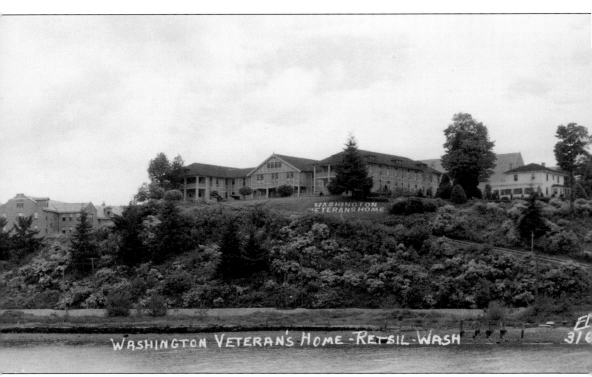

WASHINGTON VETERANS HOME AT RETSIL. By the turn of the 19th century, there was a need to provide care for the many aging and needy veterans of the Civil and Spanish American Wars. The Washington Veterans Home at Retsil (Governor Lister's name spelled in reverse) was enabled through an act of the 1905 state legislature. The act specified that the facility was to be built for the veterans and their wives, located on land overlooking Puget Sound. Several communities along Puget Sound vied for the location. Retsil received the nod after much lobbying by Port Orchard businessmen, led by Guy Wetzel, Ed Howe, and J.M. Peterson. The home opened on February 12, 1910, with a residency of 127 veterans. The whitewashed rock sign seen on the hillside was created in 1926. During World War II, it was covered with brush for security reasons. Today, the home houses and cares for veterans of wars fought during the 20th and 21st centuries.

"DAD" WARNER. One of the earlier residents of the Washington Veterans Home was Civil War veteran "Dad" Warner, pictured here at the celebration of his 106th birthday in February 1936. At that time, he was the oldest veteran of the Grand Army of the Republic living at the home.

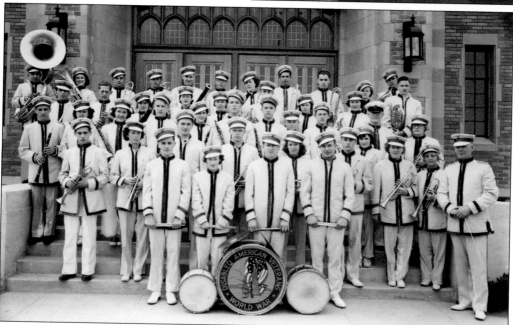

ENTERTAINING THE VETERANS. Since the establishment of the Washington Veterans Home, Port Orchard community groups have carried on a tradition of providing entertainment to the residents there. In the 1930s, a high school band poses in front of the home's auditorium.

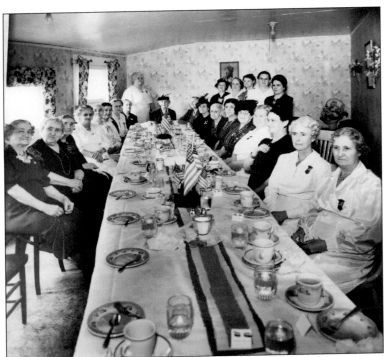

GAR Women's Auxiliary. Unlike many other veterans homes around the country, the Washington Veterans Home provided lodging and care for not only veterans but also their wives. Pictured here in 1936 is a meeting of the home's chapter of the Women's Auxiliary of the Grand Army of the Republic.

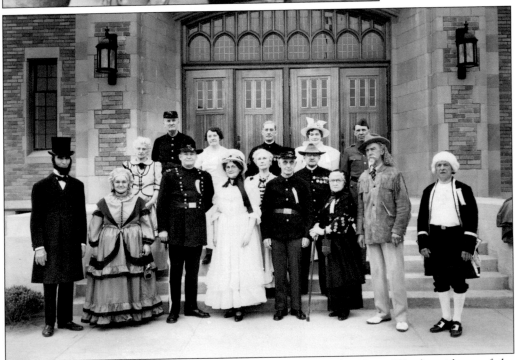

A Historical Reenactment. In this May 1938 photograph by Harry Ward, residents of the Washington Veterans Home pose in authentic clothing and uniforms from the previous century. Note the intricately crafted doors and windows of the auditorium behind them.

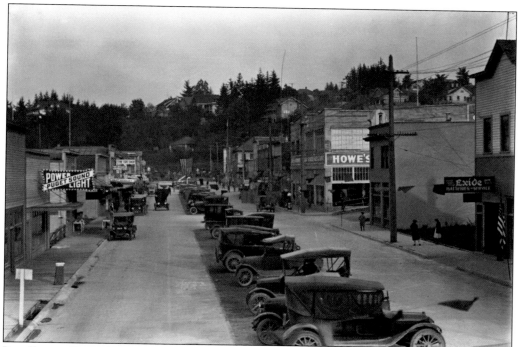

Bay Street Port Orchard, 1920s. This photograph shows the original Kitsap County Bank building to the east, next to the Exide Battery store and garage. When the State Highway Commission paved the street, it left the center portion unpaved. Note also the wooden sidewalk on the north (left) side of the street while the other side is paved. The wooden sidewalk remained because the buildings on that side of the street were still standing on underwater pilings.

Community Theatre. John McGill purchased the Star Liberty Theater in 1921. In April 1925, he moved the theater one block east to the 500-seat theater building previously erected by the Knights of Pythias and renamed it the Community Theatre. Shown here is an advertisement from the 1926 telephone directory. In 1928, the theater was again sold and renamed the D&R Theatre, a name it retained until the 1960s.

PROMOTIONAL CALENDAR. Giving free gifts has long been a custom of businesses to gain loyal customers. This 1931 calendar produced by Ainsworth Grocery Store is an example of that marketing. Note that in those days, phone numbers were only two digits.

AINSWORTH'S
PORT ORCHARD'S PIONEER GROCER
PORT ORCHARD -- PHONE 17

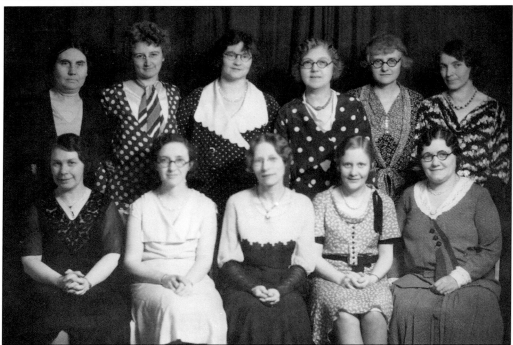

BREMERTON BUSINESS AND PROFESSIONAL WOMEN'S CLUB, 1932. Officers and the board of directors included, from left to right, (first row, seated) Dorothy Chase, Lois Pearsall, Jean Pulvermiller, Ruth Benson and Ann Alexander; (second row, standing) Norma O'Hare, Mabel Young, Vela Smith, Esther Natterlund, and Reina Osborn. In 1932, Reina (Harris) Osborn was elected treasurer of Kitsap County.

PACIFIC TELEPHONE AND TELEGRAPH OFFICE, 1930s. Katy McTavish was the manager of the Pacific Telephone and Telegraph office, and her sister Jessie was an operator. This was the first phone company in Port Orchard. The Northwest Peninsula Telephone and Telegraph Company laid a submarine cable from Bremerton during the first year of operation in 1903. In January 1927, the *Bremerton Daily-Searchlight News* stated, "the first submarine cable, though crude by today's standards, was a first and a marvel at that time."

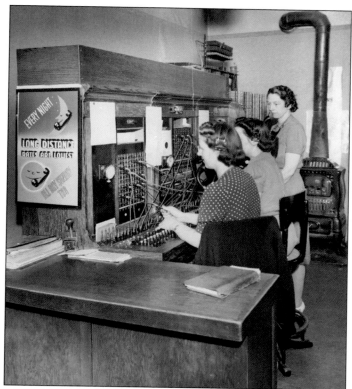

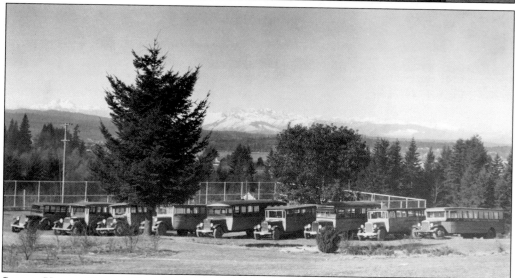

SOUTH KITSAP UNION HIGH SCHOOL BUS FLEET. The bus fleet is parked at the north end of the campus. Prior to 1930, students from the south end of Kitsap County had no transportation to high school due to the lack of bus service and also bad roads. Many students attended high school on nearby Vashon Island or boarded with relatives in Seattle or elsewhere. After 1930, school bus service became available to outlying communities such as Harper, Olalla, Burley, and Glenwood.

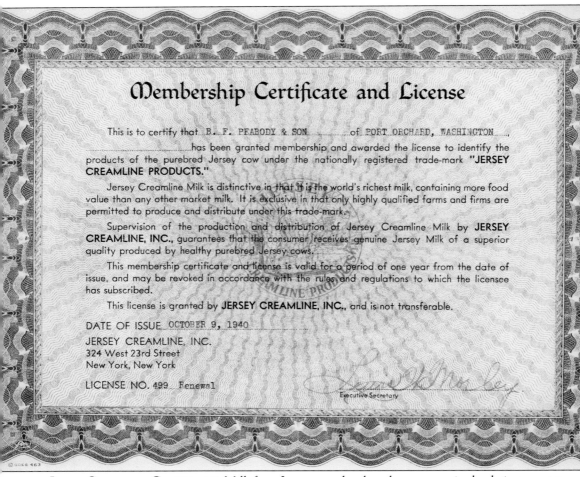

Membership Certificate and License

This is to certify that B. F. PEABODY & SON of PORT ORCHARD, WASHINGTON has been granted membership and awarded the license to identify the products of the purebred Jersey cow under the nationally registered trade-mark "JERSEY CREAMLINE PRODUCTS."

Jersey Creamline Milk is distinctive in that it is the world's richest milk, containing more food value than any other market milk. It is exclusive in that only highly qualified farms and firms are permitted to produce and distribute under this trade-mark.

Supervision of the production and distribution of Jersey Creamline Milk by **JERSEY CREAMLINE, INC.,** guarantees that the consumer receives genuine Jersey Milk of a superior quality produced by healthy purebred Jersey cows.

This membership certificate and license is valid for a period of one year from the date of issue, and may be revoked in accordance with the rules and regulations to which the licensee has subscribed.

This license is granted by **JERSEY CREAMLINE, INC.,** and is not transferable.

DATE OF ISSUE OCTOBER 9, 1940

JERSEY CREAMLINE, INC.
324 West 23rd Street
New York, New York

LICENSE NO. 499 Renewal

Executive Secretary

JERSEY CREAMLINE CERTIFICATE. Milk from Jersey cows has long been recognized as being among the world's richest milk. This certificate, issued by the Jersey Creamline Corporation in 1940, signifies that the B.F. Peabody & Son dairy of Port Orchard provided milk only from purebred Jersey cows.

EARLY SAWMILL. With the early development of Sidney came two sawmills and two shingle mills to accommodate the burgeoning timber industry. Pictured here in the 1930s are the remains of a shingle mill at the west end of the Port Orchard waterfront.

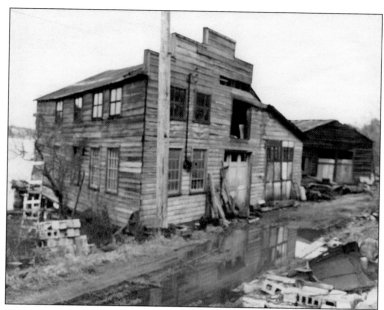

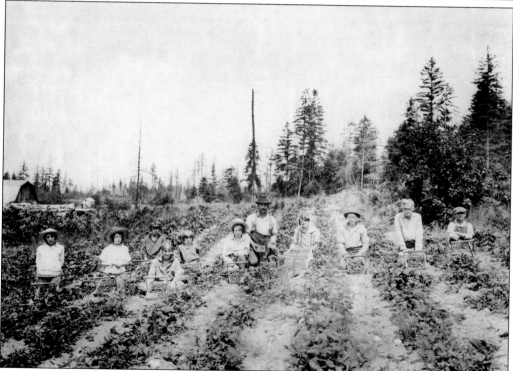

STRAWBERRY PICKERS. During the 1920s and 1930s, area strawberry farmers shipped out many thousands of flats of fresh strawberries. In 1928, the strawberry pickers at the S.J. Ives Farm just outside Port Orchard included, from left to right, Mary Pieren, Gudrun Reite, Pearl Ives, Florence Pearson, Alma Reite, Ruth Ames, S.J. Ives, Ruth Balcom, Claude Ives, Ralph Reite, and Walter Pieren.

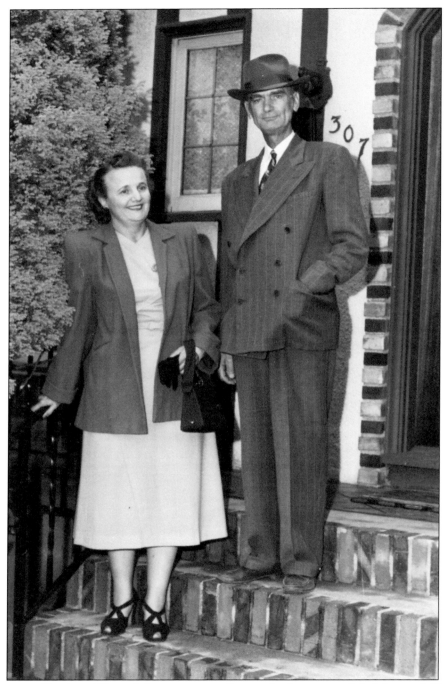

THE LANGERS. Frank and Hannah Langer are standing on the front steps of their home. A Harvard Law School graduate and decorated World War I veteran, Langer purchased the controlling interest in the Kitsap County Bank in 1922. He ran the bank until his death in 1952. Upon his death, his widow, Hannah, retained controlling interest in the bank and served as its president until 1972. She is believed to have been the first woman bank president west of the Mississippi.

THE METHODIST EPISCOPAL CHURCH. Sidney's Methodist church was built at Kitsap and Sidney Streets in 1890 on property donated by Ira Rockwell, the first mayor of Sidney. In 1929, the church was destroyed by fire. In 1930, the cornerstone of a new church was laid and a new church built. Since then, this church has been known as Port Orchard's downtown church.

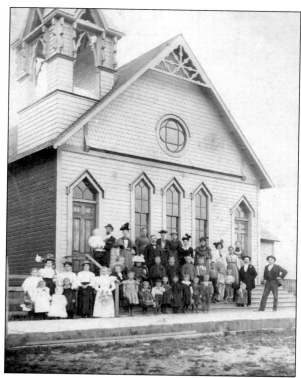

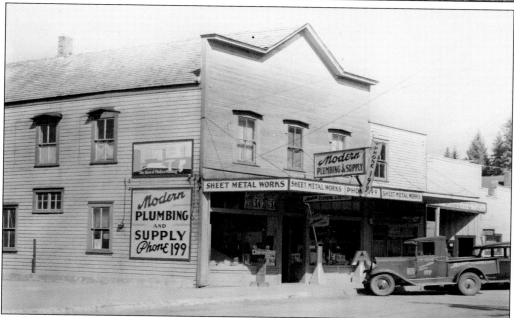

MODERN PLUMBING AND SUPPLY. Located on Bay Street near Frederick, this 1930s photograph shows the three-digit phone number displayed on the wall. The Soo Hoy Restaurant, operated by the Ojima family from the 1940s to the 1980s, was later housed in this building. The building still stands today and is one of the oldest in Port Orchard.

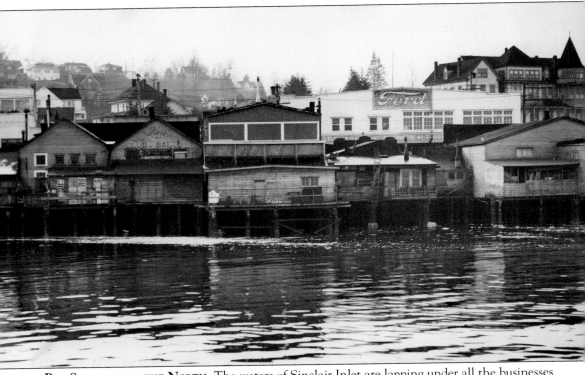

Bay Street from the North. The waters of Sinclair Inlet are lapping under all the businesses on the north side of Bay Street in the 1930s. The area of water in the foreground has since been filled and turned into a parking area. The venerable Sidney Hotel in the upper right is beginning to show its age.

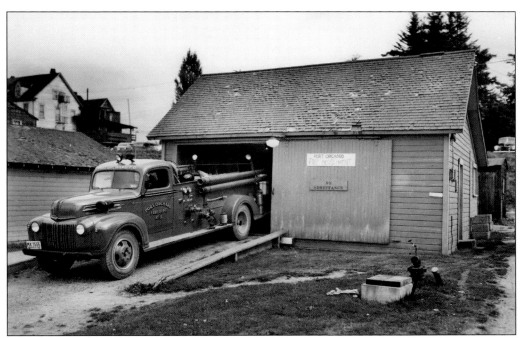

PORT ORCHARD FIRE DEPARTMENT. Port Orchard did not have a formal firefighting program until 1910, when the city purchased a two-wheel cart with a hand pump and a one-inch hose. In 1916, two more carts were procured and placed in strategic locations around town. Firefighters were anyone who happened to be in the vicinity of a fire. By 1924, a seven-man fire department had been formed. That year, the department acquired its first motorized fire truck. By the 1930s, the city had built Fire Department No. 3 at the top of Sidney Hill near the courthouse, as shown in the photograph above, and a downtown station at the bottom of Sidney Street, as shown in the photograph below. Today, South Kitsap Fire and Rescue serves over 70,000 citizens with 16 stations covering 122 square miles.

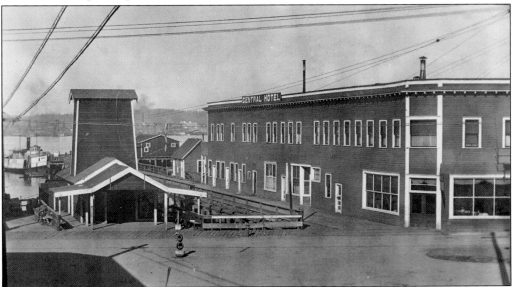

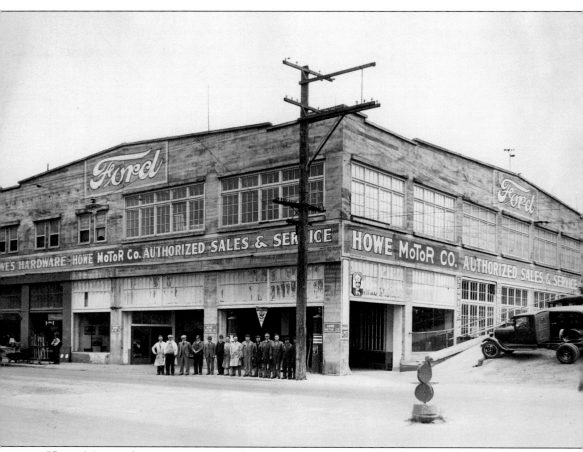

HOWE MOTOR COMPANY. In 1928, the Howe Hardware and Howe Motor Company moved its business operations across the street and built a much larger concrete block building, which occupied nearly half a city block. The Ford dealership took up most of the first floor, with the hardware store operating from space on the east end, as shown in this photograph. Standing in front of the new building is the service and sales staff. On the far left is Dean Corliss. Owner Edwin Howe would eventually move the automobile dealership portion of the business to a new location at the east end of town, near Blackjack Creek.

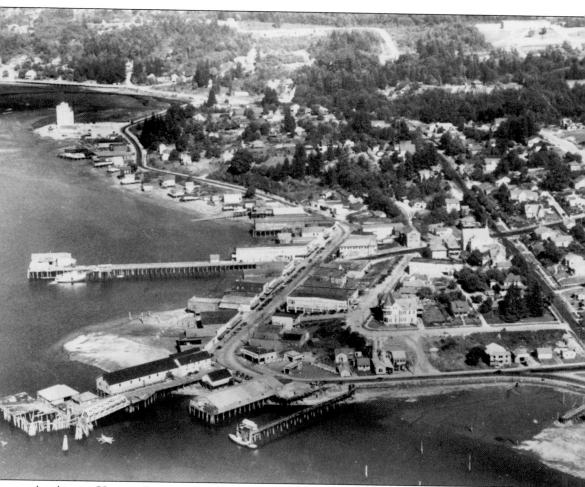

AN AERIAL VIEW OF PORT ORCHARD. The Central Pier at the foot of Sidney Street is seen in this 1930s photograph by Northwest Air Photograph. Moored at the end of the pier is the Mosquito Fleet ferry *Carlisle*, which was owned by the Horluck Transportation Company. At the upper left is the Silver Springs Brewery, which manufactured beer from 1934 until 1950. The cleared area at the upper right is South Kitsap High School. On the lower left is the loading ramp for the early car ferry, the *H.B. Kennedy*.

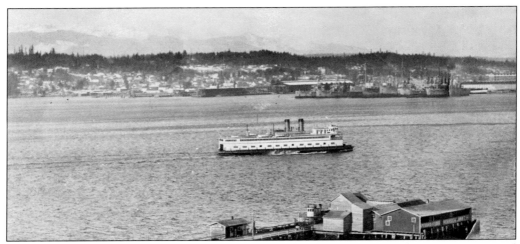

EARLY CAR FERRY. During the early 1930s, a number of Mosquito Fleet steamboats were converted to automobile ferries. Pictured here is the *H.B. Kennedy* shortly after leaving the dock near the foot of Frederick Street on its way to West Seattle. Peninsula Grain used the *Kennedy* to transport truckloads of crated eggs to Seattle where they were shipped by train to markets in the Midwest. On the lower right are the Central Dock and the Peninsula Grain Company building. (Courtesy of Vaughan Collection.)

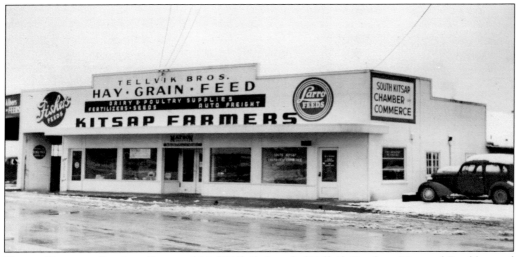

KITSAP FARMERS. Brothers Stan and Mal Tellvik founded Tellvik Brothers Hay and Feed located at 605 Bay Street. The fact that there were at least three grain and feed stores in and around Port Orchard during the 1930s indicated the extent of the area's agricultural heritage.

Four

1941–1960s

Port Orchard experienced an unprecedented influx of residents during World War II due to the need for thousands of more workers at Navy Yard Puget Sound. This required the US government to build two temporary housing developments at the east end of town. By 1945, employment at the shipyard exceeded 30,000. By the 1950s, the tide flats on the north side of town were filled in, including the Westbay Shopping Center on the east shore of Blackjack Creek. During the 1970s, the port of Bremerton built a large public marina in Port Orchard adjacent to the filled-in area, featuring a 3,000-foot guest dock. By the late 1970s, most of the retail establishments had lost out to the emerging suburban shopping malls. Today, antique stores, galleries, and restaurants occupy many of the buildings formerly used as hardware, grocery, and department stores.

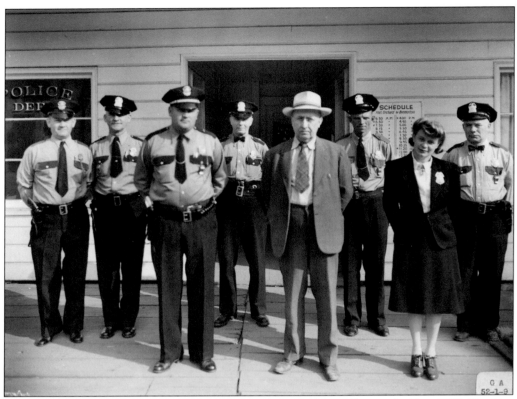

PORT ORCHARD POLICE DEPARTMENT, 1941. From left to right are (first row) officer W.H. Hankin, Mayor C.A. Hanks, and office manager Lolita Bliss; (second row) officers James Frakes, Charles Heath, Ben Lundberg, ? Holtorf, and Paul Nesseth. The sailing schedule for the Port Orchard to Bremerton foot ferry is attached to the wall near the entrance.

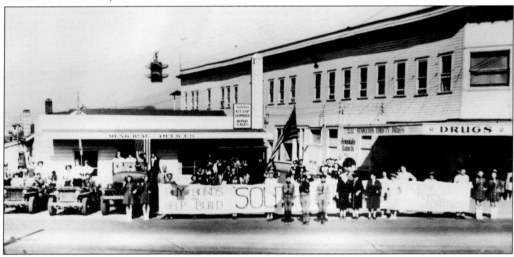

BUY WAR BONDS. Pictured here during World War II is the South Kitsap High School Band selling war bonds to build B-17 Flying Fortress bombers. Behind them is the city hall. To the right are the Central Hotel and Stapleton Drugs, the predecessor of the Hannah and Powell Drug Store.

SHORE PATROL DURING WORLD WAR II. With the thousands of sailors stationed at Navy Yard Puget Sound during the war, the Navy Shore Patrol played a large role in maintaining law and order. Here, shore patrol sailors pose in front of the Port Orchard Police Station at Christmas time. The Central Hotel stands in the background.

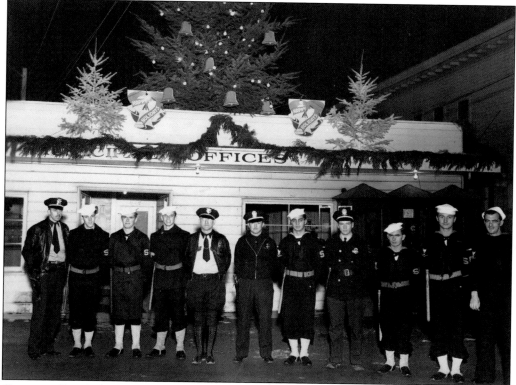

COMBINED LAW ENFORCEMENT, 1945. During World War II, Kitsap County's population exploded due to the influx of workers at Navy Yard Puget Sound. At the same time, many law enforcement personnel were away helping with the war effort. Therefore, shore patrol sailors from the Navy Yard Puget Sound were recruited to augment civilian law officers. Shown here, shore patrol sailors pose for a holiday photograph along with Port Orchard police officers.

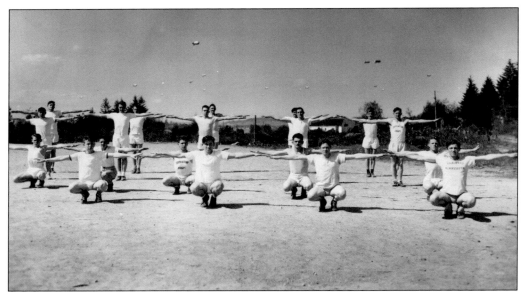

BARRAGE BALLOONS. A boys' physical education class at South Kitsap High School performs calisthenics in 1945. In the background, World War II barrage balloons can be seen floating over Navy Yard Puget Sound across the bay.

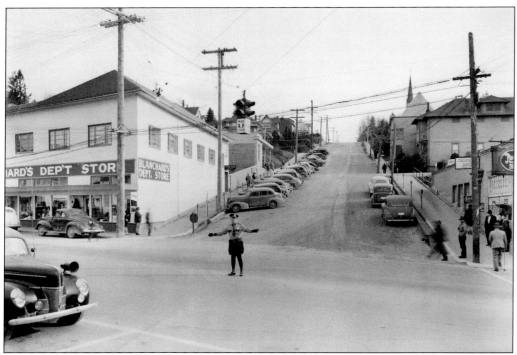

PORT ORCHARD TRAFFIC CONTROL. An officer directs traffic at the intersection of Bay and Sidney Streets in the 1940s. The intersection looks nearly the same now as it did then, except the Rexall Drugs on the far right is now a bicycle shop and Blanchard's Department Store on the left now houses several antique shops.

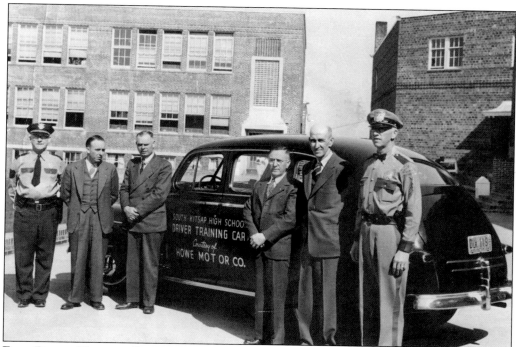

FIRST DRIVER-TRAINING PROGRAM AT SOUTH KITSAP. South Kitsap High School began its driver-training program in 1947. Howe Motors provided the training car. Pictured from left to right are officer Charles Heath, Gordon Howe, principal Joe Knowles, Howe Motors founder Edwin Howe, D.K. Rees, and Washington State patrol officer John Williamson.

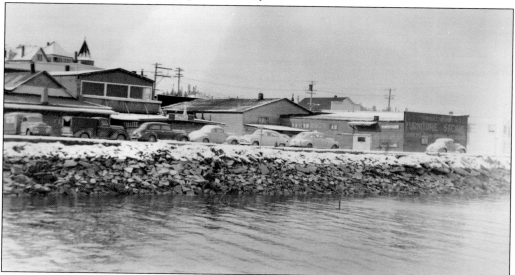

PORT ORCHARD WATERFRONT, C. 1950. By the late 1940s, the entire beach frontage on the "water side" of Bay Street had been filled in with rock and other fill material. This more than doubled the square footage of downtown Port Orchard. Shown after a light snowfall is the newly created parking area. Today, this area is also used for musical events, a seasonal farmers market, and a world-class car show. A large marina and waterfront park have also been added.

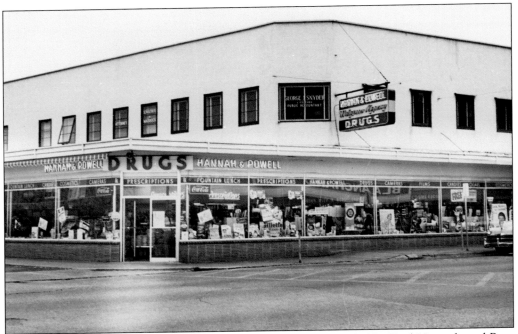

HANNAH AND POWELL DRUGS. Hannah and Powell Drugs, founded by Fred Hannah and Ross Powell, was a fixture in downtown Port Orchard from the 1940s through the 1970s. The soda fountain at the back of the store was a popular destination for local teenagers. The store was originally built as an add-on to the Central Hotel. At the time of this photograph, the hotel had been converted to office space.

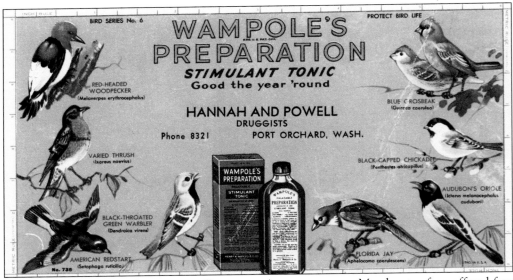

HANNAH AND POWELL COLLECTING CARD AND ADVERTISEMENT. Merchants often offered free gifts to entice customers to return and collect the entire set. Shown here is Hannah and Powell Drugs's "Bird Series Number 6" advertising Wampoles Stimulant Tonic and featuring metric and inch rulers in the margins.

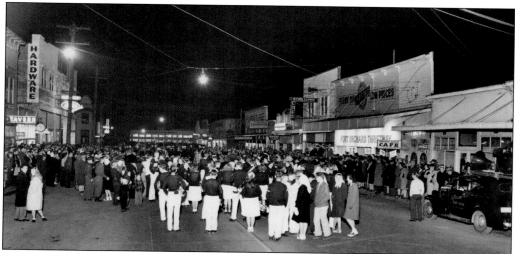

GALA OPENING OF PORT ORCHARD THRIFTWAY. Pictured here in the 1940s, the new Port Orchard Thriftway is flanked by Orphan Annie's Café and Star Cigar & Café. Ainsworth Grocery Store is seen at the bend in the street. In a few years, the Thriftway would become Winebrenner's Grocery Store, one of Port Orchard's most prominent businesses during the 1950s and 1960s.

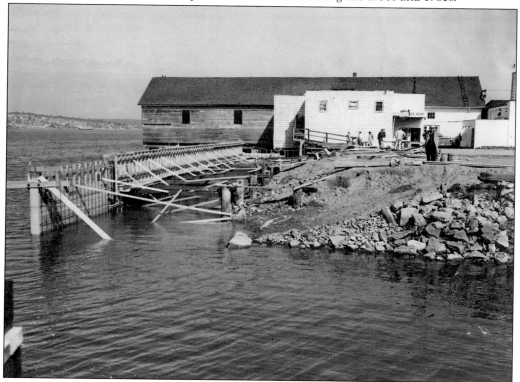

FILLING IN PORT ORCHARD'S WATERFRONT. Over the years, the City of Port Orchard gradually filled in the beach frontage on the north side of town, and the buildings that had once stood on pilings over the water were then landlocked. Here, forms have been built for a bulkhead to contain fill material.

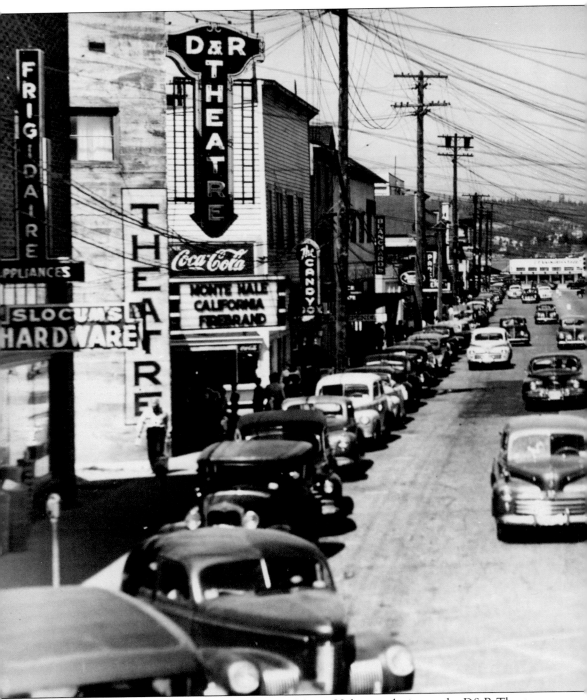

D&R Theatre. *California Firebrand,* starring Monty Hale was playing at the D&R Theatre on this date in 1948. Hale was a Western movie star from the 1940s. The D&R Theatre was founded by Rex Thompson and J.G. Beckman in 1928 in the theater and lodge building constructed by the Knights of Pythias in 1925. Thompson named it D&R after his twin sons, Don and Ron. The

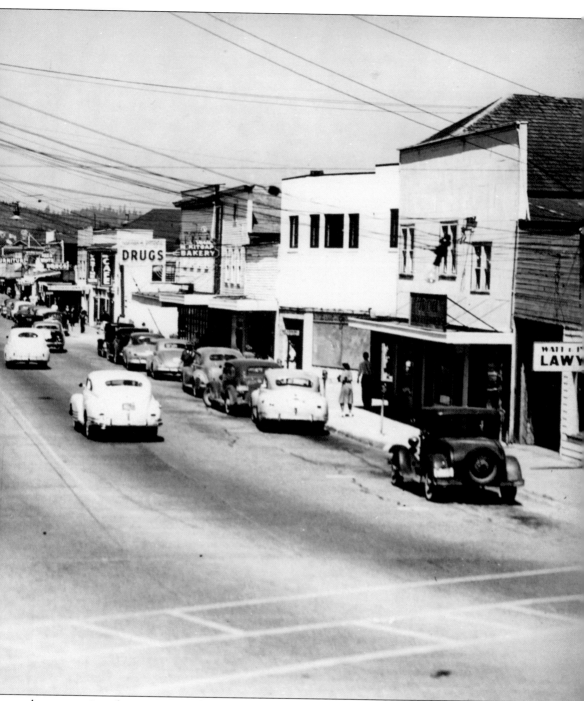

theater continued to operate until 1965, when maintenance problems and competition from larger theaters forced it to shut down. The theater was reopened as the Plaza Twin Theater in 1980 and since then, has continued to operate under several new owners and names.

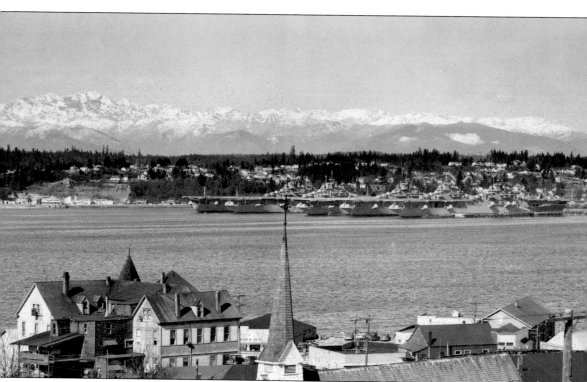

OLYMPIC MOUNTAIN VIEW. This magnificent 1946 panorama shows the Olympic Mountain Range from partway up Sidney Hill. Moored at the Puget Sound Naval Shipyard are several war ships and aircraft carriers awaiting post–World War II transfer to the "Mothball Fleet." In 1945, the Navy changed the name of its Puget Sound shipyard to Puget Sound Naval Shipyard (PSNS).

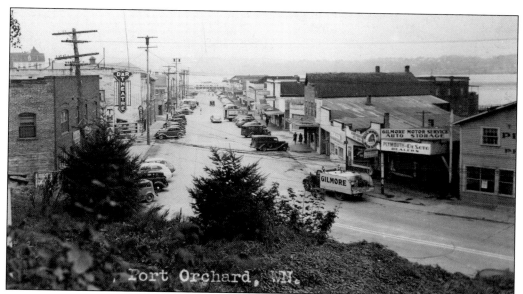

BAY STREET, 1940s. Gilmore Automotive Service in the foreground was the successor to Wilson Motor Company, which had been a Chevrolet dealership. Slocum's Hardware in the brick building across the street was established in 1924, near where the Holland House hotel stood. Notice that for a time in the 1940s, parking was changed from parallel to angle, and parking meters were no longer in use.

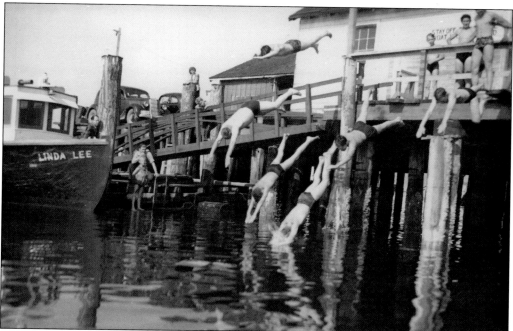

DIVING FROM THE FERRY DOCK IN PORT ORCHARD. Youngsters are seen diving from Central Dock into the frigid 50-degree water of Sinclair Inlet in the 1940s. On the left, the *Linda Lee* was owned by Horluck Transportation Company and was used to ferry passengers across Sinclair Inlet to Bremerton.

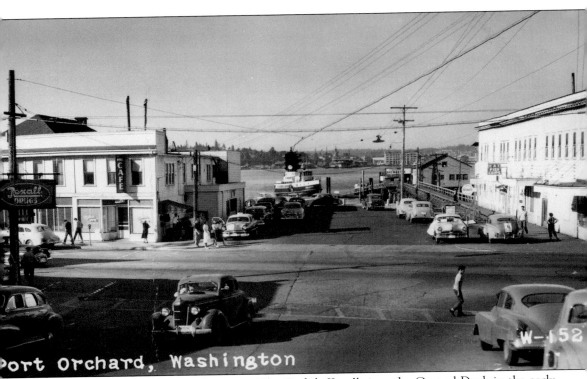

Port Orchard, Washington

HORLUCK TRANSPORTATION COMPANY. The *Carlisle II* pulls into the Central Dock in the early 1950s. *Carlisle II* was part of the Horluck Transportation Company fleet, which was owned and operated by the Nearhoff and Lieseki families from the mid-1920s to the mid-1990s. The Horluck boats carried passengers daily on the Port Orchard to Bremerton and Annapolis to Bremerton foot-ferry runs. Built in 1917, *Carlisle II* has now been repowered and refurbished and continues to carry passengers from Port Orchard to Bremerton under the ownership of the Kitsap Transit System.

PRICE'S GOLDEN GUERNSEY DAIRY. Price's Dairy was the principal supplier of dairy products to families in Port Orchard and the environs for over 40 years. The farm included a processing plant for dairy products and provided daily home delivery for much of Kitsap County. Shown on this calendar cover from around 1952 are Price family members with their prize golden Guernsey cows at the Western Washington Fair at Puyallup, Washington.

THE PRICES (another year older) at Western Washington Fair

(Western Glow Constance) (Western Glow Country Rosette) (Western Glow Royal Glenda) (Price's Golden Sweetheart)
BETTY-LEE BOB DON DOUGLAS

PRICE'S GOLDEN GUERNSEY DAIRY

"Guernsey Milk from Approved 100% Guernsey Herds"

Telephone — Plant and Office: Port Orchard 6-3202

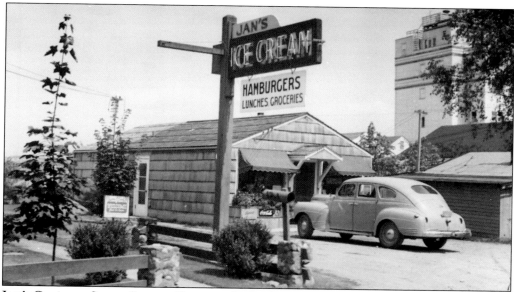

JAN'S CAFÉ AND SILVER SPRINGS BREWERY. In the foreground is Jan's Café, located on Bay Street Near Rockwell Avenue. The Silver Springs Brewery is in the background. The brewery, located adjacent to Blackjack Creek, was established in 1933 shortly after the repeal of Prohibition. The site for the brewery was chosen for the artesian well water available there. During the brewery's heyday, Port Orchard's Peninsula Feed delivered barley by the truckload from mills in Vancouver Washington. At one time, it was the tallest building in Kitsap County. The brewery operated until 1950. When it closed down, the building was razed.

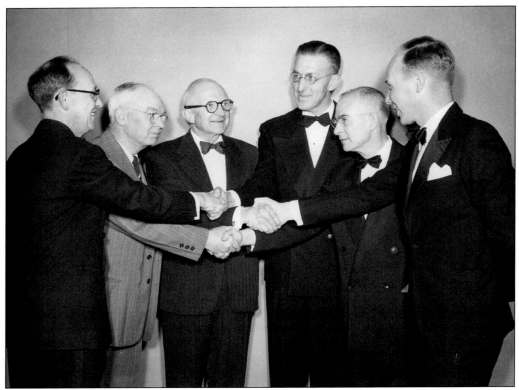

A Judicial Gesture. State, county, and municipal judges gathered in 1952 with members of Kitsap County Bar Association and their wives at the Elks Club to honor Judge H.G. Sutton for 25 years of continuous service on the Kitsap Bench. Pictured here are, from left to right, Kitsap County judge Frank W. Ryan; Judge H.G. Sutton; Judge Max Church of Clallam/Jefferson Counties; state supreme court justices from Olympia Ralph O. Olson and Frank P. Weaver; and Bremerton municipal court judge Oluf Johnsen. (Courtesy of *Bremerton Sun*, March 22, 1952.)

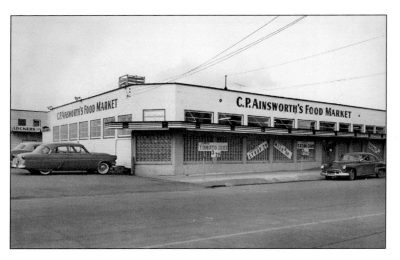

C.P. Ainsworth's Food Market. The Ainsworth Store continued under Ainsworth-family ownership until 1973, becoming one of the oldest and largest stores in Kitsap County. This early 1950s photograph shows a larger store with cold storage lockers.

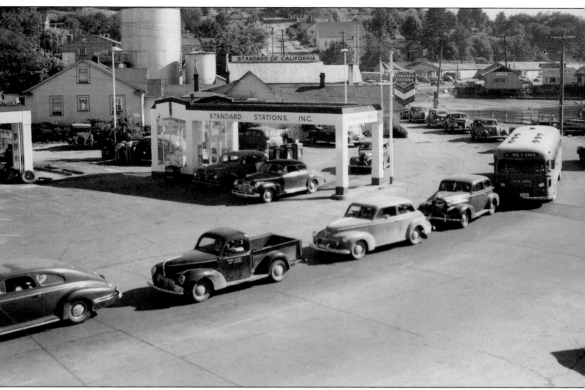

NAVY YARD TRAFFIC. Port Orchard has long been a bedroom community for workers at the Puget Sound Naval Shipyard. Pictured here in the late 1940s, a long line of commuters head east through Port Orchard after a day's work at "the yard." The bus in the photograph carried shipyard workers to outlying communities, in this case, View Park at the south end of the county. The Standard gas station at center is now the site of the city hall.

SCHOOL SAFETY PATROL SAFETY CERTIFICATE. During the 1940s and 1950s, a number of students at South Kitsap Schools were appointed to School Safety Patrol, helping younger students cross busy intersections on their way to school. A safety patrol certificate signed by Art Grosso, a longtime teacher, coach, and principal at South Kitsap High School, is presented to Robert Meitzner in 1948.

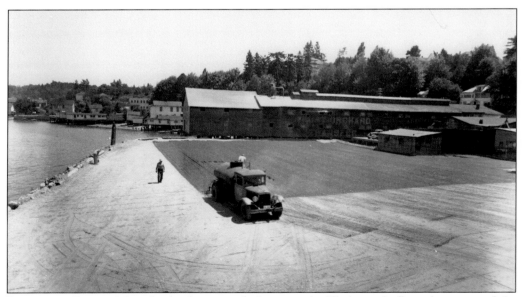

PENINSULA FEED, 1950s. In the foreground, the recently filled-in tide flat is being paved. In the background, the signage from 1906 for Port Orchard Transfer can still be seen. At the outside (left) end of the building, Peninsula Feed has added on a new wing. (Courtesy of Don Vaughan Collection.)

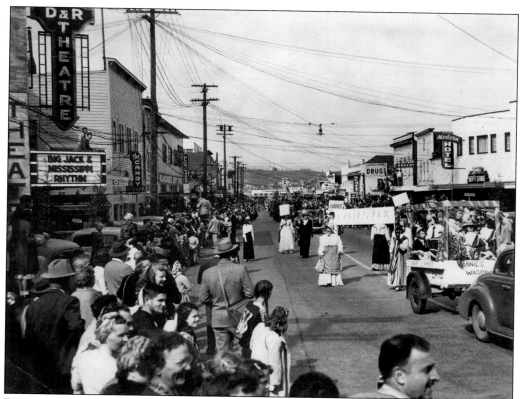

PARADE, DAYS OF 49. The Days of 49 celebration was a very popular event in Port Orchard from the 1940s into the 1960s. The name actually had no connection with Port Orchard. Celebration founders chose it simply because no other town had claimed it. Pictured here in 1953, the Days of 49 parade travels east on Bay Street. In the foreground to the left is the D&R Theatre, which was a very popular Saturday afternoon destination for youngsters growing up in Port Orchard. In the photograph below, queen Jackie Adkins rides on the Active Club and Kiwanis Club float. Service clubs have long been a feature in Port Orchard, including the Knights of Pythias, the Rotary, the Chamber of Commerce, the Active, and Kiwanis Clubs.

COSTUMES, DAYS OF 49. The Days of 49 celebration gave Port Orchard townsfolk an excuse to dress up in Western garb, including handguns for the men. Pictured here in 1952, Dusty and Lola Winebrenner are on the far left, posing in front of their store, Winebrenner's Grocery on Bay Street. On the far right is Hazel Belnap Simmons, Lola Winebrenner's sister. Dusty Winebrenner served two terms on the Port Orchard City Council in the 1940s and 1950s.

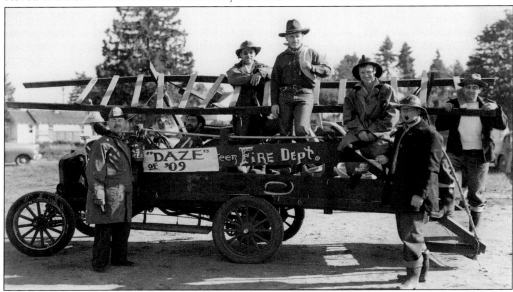

FIRE DEPARTMENT FLOAT, DAYS OF 49. This 1950 Days of 49 parade included an antique fire truck, purported by the participants to be the first fire engine in Port Orchard not powered by horses.

BETHEL GRANGE FLOAT, DAYS OF 49. For this early 1950s parade, Grange members used local huckleberry foliage as well as hemlock branches to decorate a float, boasting an early settlers theme. Musical instruments include a washboard used by the musician nearest the stove. Over the years, Grange organizations have thrived around Kitsap County based on its agricultural heritage

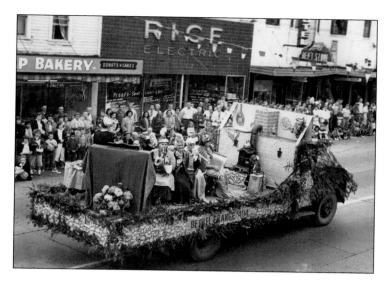

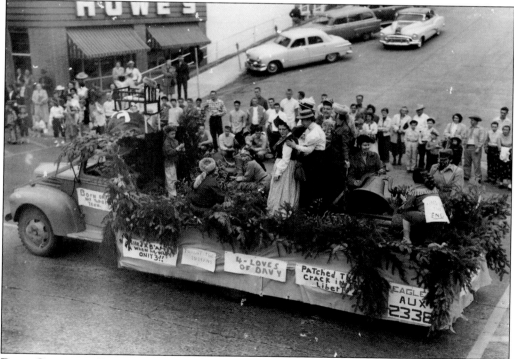

DAVY CROCKETT FLOAT, DAYS OF 49. For the 1955 parade, the Eagles Auxiliary created this float based on the popular Walt Disney television series *Davy Crockett*. Notice the buckskin and coonskin hats. The liberty bell replica at the back of the float pertains to a lyric of a then popular song titled *The Ballad of Davy Crockett*, which claimed he "patched up the crack in the Liberty Bell."

SHERIFF'S POSSE ON HORSEBACK. The Kitsap County Sheriff's Posse passes the reviewing stand in the 1950s parade. Local horse owners formed the posse in part to aid law enforcement. The posse was occasionally called out by the Kitsap County Sheriff to help with search and rescue missions.

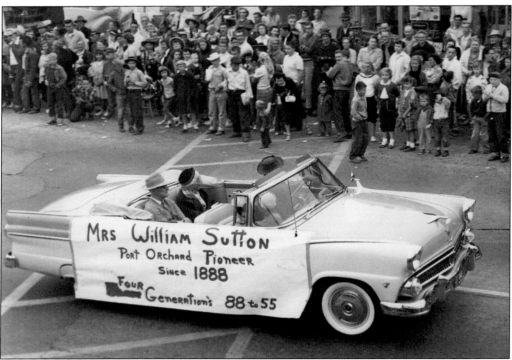

WILLIAM AND MARY SUTTON. Port Orchard pioneer Mary Sutton is featured in the 1955 Days of 49 parade. She came to Port Orchard in October 1888 with her husband, William. They built their first home on Division Street, near the county courthouse. William Sutton worked as a carpenter at the Puget Sound Naval Shipyard and was eventually the first worker there to retire with a pension. He also served on the Port Orchard City Council in the 1920s. The Suttons' daughter Chloe Sutton served as town clerk of Port Orchard in the 1950s and was the founder and first president of the Kitsap County Historical Association (now Society) from 1949 to 1954.

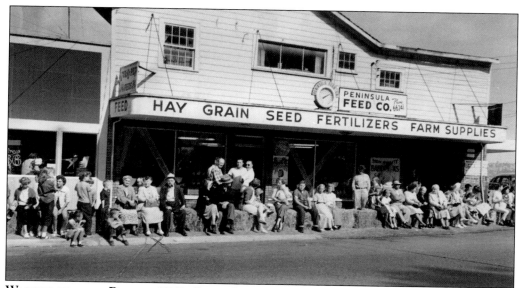

WAITING FOR THE PARADE 1958. Days of 49 parade watchers along Bay Street relax on hay bales provided by Peninsula Feed Co. On the far right, around the corner of the Peninsula Feed Building, a water fountain ran continuously. Visitors were always welcome to a drink of fresh, artesian mineral water.

BEARD-GROWING CONTEST WINNER. One of the features of the Days of 49 celebration was a beard-growing contest. In the 1950s, a contest winner accepts his trophy from the grand marshal. The celebration also featured a symbolic old West jail where merchants who had not contributed to the event were locked up for an hour or so. In the early 1960s, the Days of 49 celebration was replaced by the Fathoms of Fun festival, which was considered to be more family friendly.

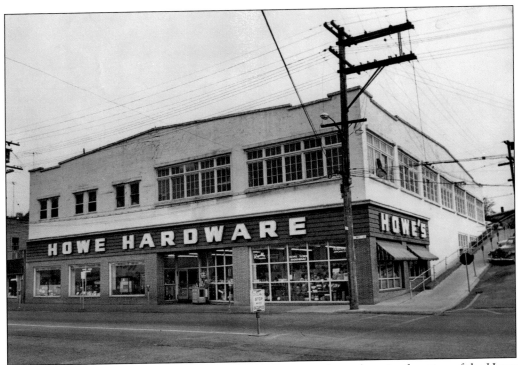

HOWE HARDWARE, C. 1950S. By the 1950s, the automotive sales and service function of the Howe enterprises had been completely separated from the hardware business and operated from a new site at the east end of town under the name, Howe Motors. The Howe Building appears here in the 1950s, when it was totally devoted to hardware. Also, note that the City of Port Orchard has reinstated parking meters.

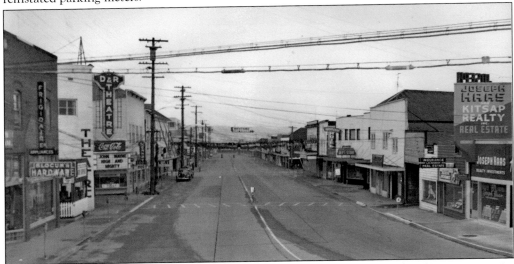

AIR RAID EVACUATION, 1954. During the Cold War of the late 1940s and 1950s, communities around the United States prepared for the possibility of an atomic bomb attack by the Soviet Union. Children were taught in school to "duck and cover." Families built bomb shelters in their back yards. Towns held air raid evacuation drills. Here, Bay Street appears eerily quiet during one such drill.

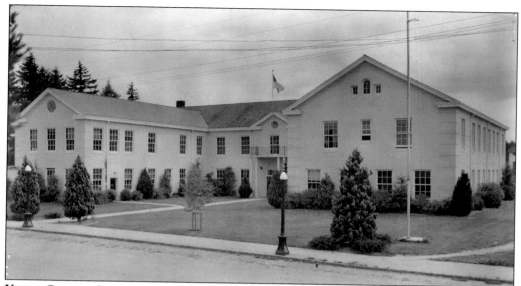

KITSAP COUNTY COURTHOUSE, 1943. This building was completed in 1930 to replace the original courthouse built by Sidney residents in 1893. The much larger fireproof structure was built around the former courthouse, which was then razed.

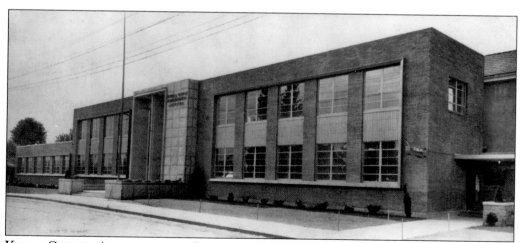

KITSAP COUNTY ADMINISTRATION BUILDING, 1949. An addition to the building completed in 1930, this brick building was completed in 1949. Designated as the Kitsap County Administration Building, it housed all of the county's administrative, judicial, and law enforcement functions until 2006, when many of these offices were moved to a new administration building across the street.

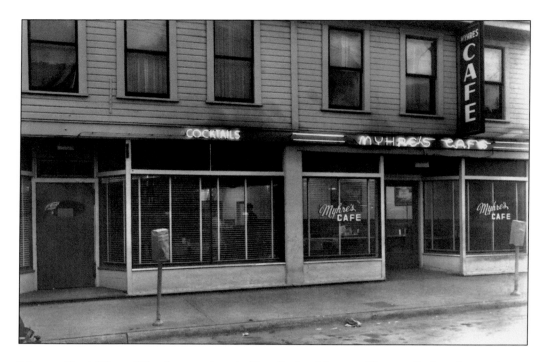

MYHRES CAFÉ. The café has been an icon in Port Orchard for over 80 years. Built at the northwest corner of Bay and Sidney streets in 1927, the café has served as a morning coffee stop for many generations of Port Orchard old-timers. The bar has long been a popular afternoon and evening gathering place. The café has provided jobs for hundreds of employees, some of whom remained for more than 30 years. Myhres has survived three major fires over the years. Above is Myhres as it looked in the 1930s. Below is the café as it looked in the 1960s.

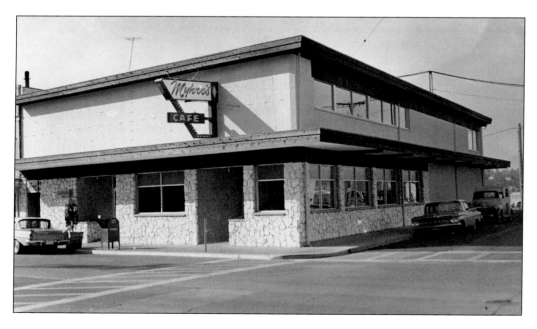

DONKEY BASKETBALL. Donkey basketball games were a popular school fundraiser during the 1950s and 1960s. Pictured is a game played at South Kitsap High School around 1961. Participants include teachers Lloyd Pugh on the far left with the cane; Orville Anderson on the front donkey shooting at the basket; and Buck Gehring, the second nearest donkey to the stage.

PRIZE-WINNING DURHAM AT KITSAP COUNTY FAIR. Dairy farming has long been prominent in the communities surrounding Port Orchard. Livestock, small fruits, bulbs, holly, Christmas trees, and hatcheries for both chickens and turkeys all contributed to the farming industry. In 1952, Capt. Donald K. Ross, retired US Navy, and his wife, Helen, purchased 40 acres near Port Orchard and ran a Grade-A dairy. Ross, a Medal of Honor recipient from World War II, developed some exceptional polled Durham cattle, some of which were exhibited and received blue ribbons as far away as Ohio. Here, their son Robert shows one of the award-winning Durham Cattle in the 4-H division at the Kitsap County Fair.

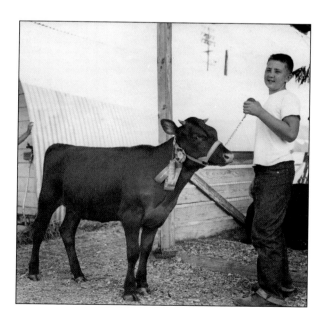

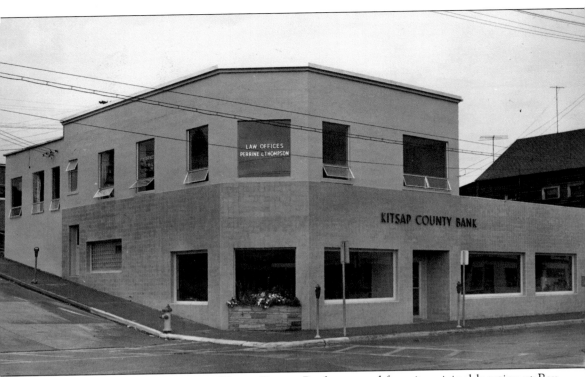

KITSAP COUNTY BANK, 1960s. Kitsap County Bank operated from its original location at Bay and Frederick Streets from 1908 until 1977. By 1963, the bank had expanded to the south and up the hill on Frederick Street. In 1977, the bank moved into its current headquarters across Bay Street near the former site of the Ainsworth Grocery Store.

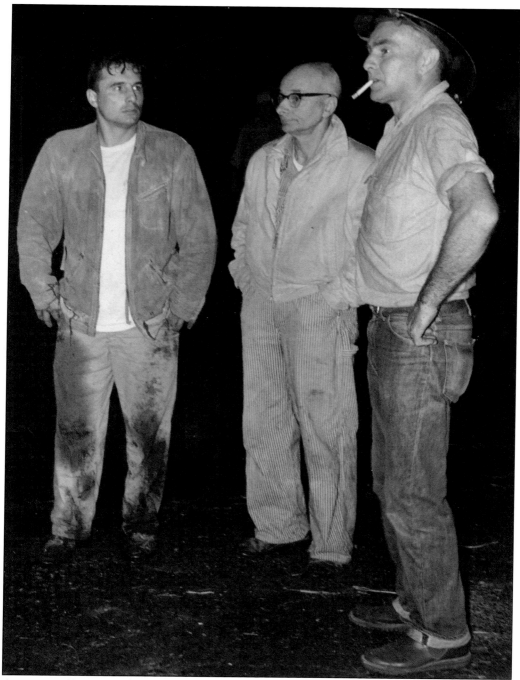

AFTER THE FIRE. Two fires, one in 1965 and another in 1967, destroyed Peninsula Feed's hay barn and grain mill. Surveying the damage after one of the fires are, from left to right, owners Don Vaughan and his father, Clyde Vaughan, along with 40-year employee Frosty Adkins. The business was rebuilt at a new site across the parking lot and continues today as a retailer of feed and power equipment. (Courtesy Don Vaughan Collection.)

DISCOVER THOUSANDS OF LOCAL HISTORY BOOKS
FEATURING MILLIONS OF VINTAGE IMAGES

Arcadia Publishing, the leading local history publisher in the United States, is committed to making history accessible and meaningful through publishing books that celebrate and preserve the heritage of America's people and places.

Find more books like this at
www.arcadiapublishing.com

Search for your hometown history, your old stomping grounds, and even your favorite sports team.

Consistent with our mission to preserve history on a local level, this book was printed in South Carolina on American-made paper and manufactured entirely in the United States. Products carrying the accredited Forest Stewardship Council (FSC) label are printed on 100 percent FSC-certified paper.

MADE IN THE USA